IMAGES
of America

WESTMINSTER

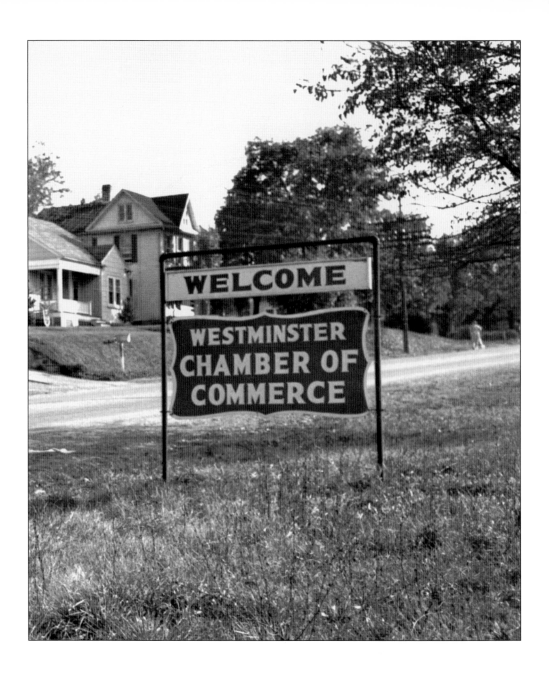

IMAGES
of America

WESTMINSTER

Catherine Baty on behalf of the
Historical Society of Carroll County

ARCADIA
PUBLISHING

Copyright © 2009 by the Historical Society of Carroll County
ISBN 978-0-7385-6608-5

Published by Arcadia Publishing
Charleston SC, Chicago IL, Portsmouth NH, San Francisco CA

Printed in the United States of America

Library of Congress Control Number: 2009924095

For all general information contact Arcadia Publishing at:
Telephone 843-853-2070
Fax 843-853-0044
E-mail sales@arcadiapublishing.com
For customer service and orders:
Toll-Free 1-888-313-2665

Visit us on the Internet at www.arcadiapublishing.com

CONTENTS

ACKNOWLEDGMENTS

The Historical Society of Carroll County has deep roots. The Society was established in 1939 "to collect and preserve all papers, books, documents or other matter or things pertaining to the history of Carroll County." Since then, the society has acquired an amazing collection, including wonderful photographs. This volume showcases the photographs of Westminster, but other images from the collection can be seen in previous volumes of this series on Carroll County and Taneytown. Thanks needs to go to the staff and volunteers who have researched the photograph collection over the years since the society's founding, including Lillian Shipley, Joanne Manwaring, Joe Getty, Jay Graybeal, Gregory Goodell, Rebecca Fifield, Tyler Boone, Mary Ann Ashcraft, Paul Wardenfelt, Jim Lightner, Jake Yingling, and many others. Each has contributed to the resources that were used in preparing the text of this book. Thanks also to those generous individuals who have donated photographs to the society over the years.

The majority of the photographs in this volume have been selected from the collection of the Historical Society of Carroll County. All photographs are from the society's collection unless otherwise credited.

INTRODUCTION

William Winchester arrived in America in 1731 as an indentured servant from London hoping to find his fortune in the New World. After completing his term of servitude, Winchester moved from Annapolis to central Maryland. In 1754, Winchester purchased 167 acres from John White for £150. The property, known as White's Level, was located along Little Pipe Creek near the boundary between Baltimore and Frederick Counties. In 1764, Winchester laid out 45 lots along the main road leading to Baltimore and, in 1768, filed a plan with what would become the State of Maryland for a town he called Westminster. The community stretched from the Manchester Road to Court Street.

Westminster's location along the road was the key factor in its early growth. A steady stream of wagons and travelers passed through, and Westminster became a convenient and comfortable place to stop. A tavern was established at the corner of what are now Main and Court Streets by the early 1770s, and other businesses and settlers soon followed.

Unlike many cities, Westminster did not develop around a central square. Instead the city grew long and narrow along the length of the road. In 1765, John White laid out 49 lots on his property called New London, which extended settlement from Court Street to Longwell Avenue. John Winters Sr. and his son John Jr. stretched the settlement further in 1812 when they created lots on their property called Bedford, which ran from Longwell Avenue to John Street. In 1825, the trustees of John Logsdon's estate carved Fanny's Meadow into town lots that were sold at public auction. These lots ran from Carroll Street to the junction of the Taneytown, New Windsor, and Uniontown Roads and along Pennsylvania Avenue to Union Street. Winchester and his son Stephen laid out 83 lots along Green Street from the Washington Road to Church Street in 1788. In 1830, all the additions were combined with the original plat when the City of Westminster was incorporated.

In 1837, Westminster was made the county seat for newly formed Carroll County. Its location at the geographic center of the new county and at the hub of a network of roads made the city an ideal choice for the seat of government. A new street, Court Street, was laid out and ran from Main Street, divided to form a square around the new courthouse, and continued beyond to the new jail. The jail was built first. Construction began in May 1837 and was completed in January 1838. Construction of the courthouse did not begin until early 1838, and the building was completed later that year. At the time, Westminster had only about 500 residents, but growth occurred quickly as homes, offices, stores, and hotels sprang up to serve those having business with the new county government.

At the western end of town, the 1840s and 1850s were a time of growth and speculation. Isaac Shriver opened a road he named Union Street, connecting Pennsylvania Avenue and West Main Street, and laid out building lots. Locals referred to that part of the city west of the Forks as Irish Town reputedly because, prior to the Civil War, brothers Dennis, James, and Terence Boylan, who came here from Ireland and helped build the Western Maryland Railroad, built homes in that area.

Much of the city's prosperity still depended on the wagons that passed through every day. As early as 1847, local citizens were investigating the possibility of a railroad to connect Westminster to Baltimore and its bustling port. In 1852, the Maryland General Assembly chartered the Baltimore, Carroll and Frederick Railroad to build a rail line west from Baltimore through Carroll and Frederick Counties to Washington County. The Maryland General Assembly changed the name of the company to the Western Maryland Railroad the following year and construction began in 1857. The railroad, which reached Westminster in 1861, cut through the center of town on its way to Union Bridge and beyond.

During the Civil War, the Western Maryland Railroad would prove vital to the Union army during the Gettysburg campaign of 1863. After the June 29, 1863, cavalry engagement in the streets of Westminster, hungry Confederate soldiers raided the warehouses beside the tracks in search of food for themselves and their horses. On July 1, 1863, Gen. Herman Haupt, chief of the U.S. Military Railroads, arrived and took control of the Western Maryland, which became the primary military supply railroad for the Union forces engaged at Gettysburg. Soon 30 trains, moving in convoys of five trains at a time, were moving 150 cars daily from Baltimore to Westminster with 1,500 tons of supplies and ammunition. Here the supplies were loaded onto wagons for the ride up the Littlestown Pike to Gettysburg. This route was also used in reverse as thousands of wounded Union soldiers and almost 7,000 Confederate prisoners came down from Gettysburg and passed through the Westminster depot until July 7.

After the Civil War, the railroad brought prosperity. Factories took root next to the tracks to take advantage of the faster, easier, and less expensive shipping provided by the railroads. The Westminster Flouring Mill, B. F. Shriver Company, Smith-Yingling and Company, Westminster Metal and Foundry Company, N. I. Gorsuch Mill, Sherwood Distillery, Carroll Mills, and the Smith and Reifsnider Coal, Wood, and Lumber Company were among those that lined the railroad tracks during the late 19th and early 20th centuries.

The railroad also brought prominent visitors to Westminster. Pres. Ulysses S. Grant arrived by rail on October 2, 1873, to visit the Carroll County Agricultural Fair. And on May 4, 1912, Theodore Roosevelt, crossing the state as part of his campaign for the Republican presidential nomination, gave a speech to an enthusiastic crowd just across the street from the railroad station.

As the city grew, other streets were laid out. Green Street was extended to Bond Street by the 1870s and eventually stretched all the way to the western edge of town. John Longwell's estate, Emerald Hill, was just a block off Main Street. The estate began at the courthouse square and stretched west, encompassing seven acres. In 1907, after the death of Longwell's daughter, the estate was divided into individual lots, creating Longwell Avenue, Willis Street, Locust Street, North Street, and parts of Center and West Streets.

Westminster's population grew rapidly in the years following World War II. The opening of the Route 140 bypass in 1954 provided a fast route to Baltimore and marked the beginning of a commuter culture, which led to the growth of homes and businesses outside the center of the city. As trucks replaced trains as the primary means of moving goods, manufacturers moved away from the railroad and closer to the highway. Today service industries have replaced manufacturing as Westminster's leading employers, but Main Street continues to thrive as the heart of a bustling city.

One

STREET SCENES

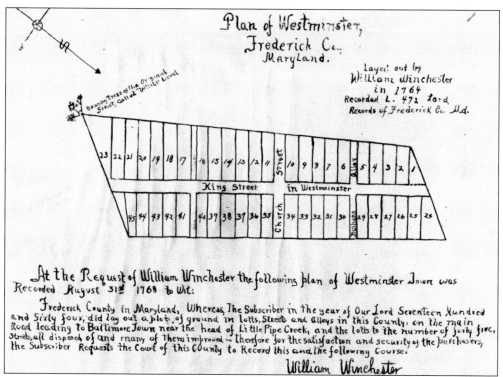

In 1764, William Winchester laid out 45 lots along the main route to Baltimore (designated King Street) and three smaller cross streets (Bishop Alley, Church Street, and Store Alley). In 1768, Winchester filed the above plan with the colonial government. Around the time of the American Revolution, King Street was renamed Main Street. Store Alley eventually became known as Ralph Street, but Bishop Alley and Church Street retain their original names.

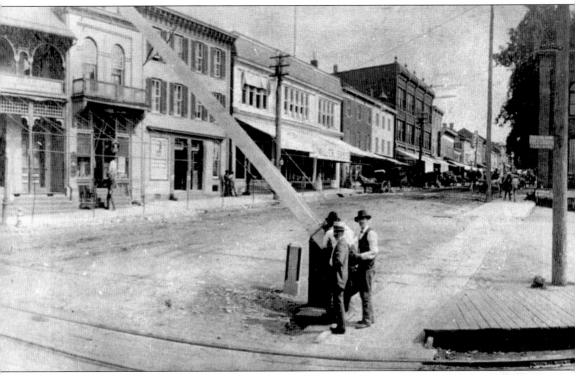

In 1852, the Maryland General Assembly chartered the Baltimore, Carroll and Frederick Railroad for the purpose of building a rail line west from Baltimore to Washington County. The Maryland General Assembly changed the name of the company to the Western Maryland Railroad the following year and construction began in 1857. The railroad reached Westminster in 1861 and Union Bridge in 1862. In Westminster, the tracks crossed Main Street at an angle near Liberty

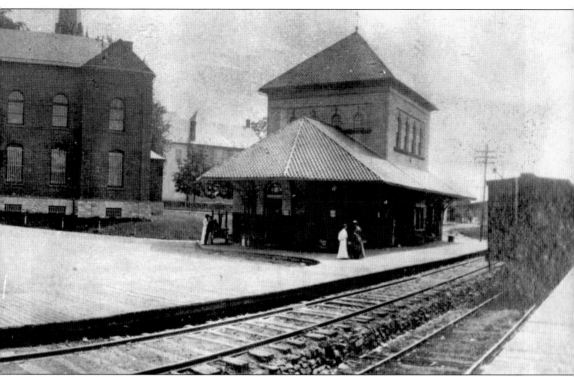

Street. Soon factories grew up along the tracks, with sidings leading directly to their loading docks. Hotels sprang up around Westminster to accommodate the travelers arriving by rail. This panoramic view looking east on Main Street was taken *c.* 1900 and shows the railroad crossing, with the passenger station at right.

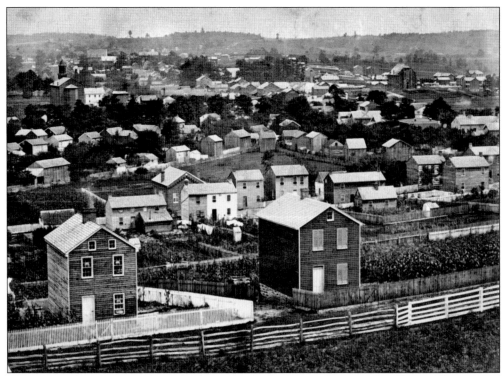

This extraordinary image from the late 1860s, taken from the top of College Hill, is one of the earliest known views of Westminster. In the right background, St. Paul's United Church of Christ can be seen when it was still under construction, with its roof covered with boards and its steeple not yet completed. In the left background, the rear of the original Grace Lutheran Church is visible.

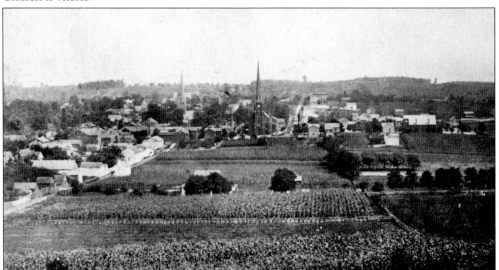

This stereograph dates to the 1870s. In the center rises the steeple of St. Paul's United Church of Christ, at the corner of Bond and Green Streets. At this time, Green Street (at the center of the image) ends at Bond Street, and farm fields stretch right to the edge of the city. To the left of St. Paul's is the steeple of St. John's Roman Catholic Church on Main Street.

A depot for the Western Maryland Railroad was constructed on the east side of the tracks on the south side of Main Street. As seen in this photograph taken by a student at Western Maryland College, the depot was a small frame building with an ornate cupola. In 1896, when construction of a new depot began, the old depot was dismantled and reassembled in New Windsor.

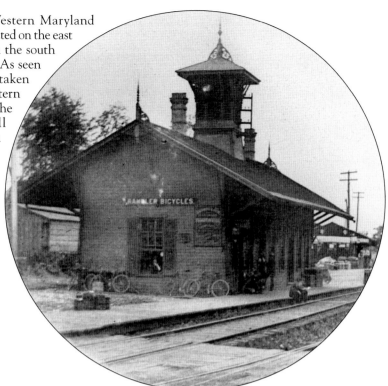

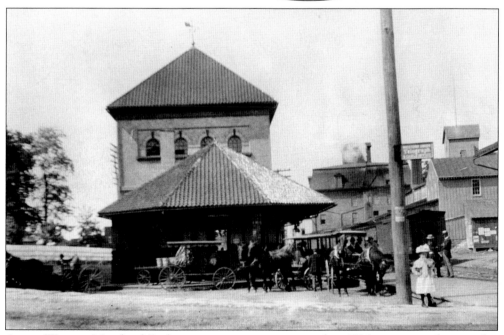

A new Western Maryland Railway passenger station opened in 1896 to great acclaim, and it quickly became a center of activity. In this 1900 photograph, 7-year-old Treva Yeiser (wearing a new hat) waits on the platform to bid farewell to her father, George W. Yeiser, of Union Mills. Yeiser closed his store for five months in 1900 and set off on a voyage to the Holy Land.

13

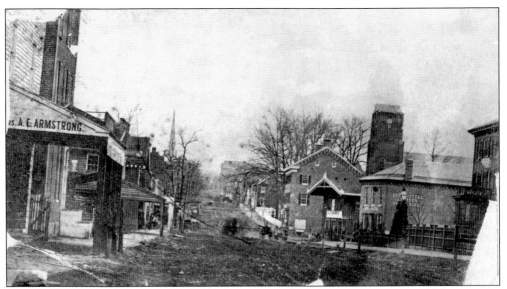

This late-1860s view, looking east, shows the intersection of Main and Liberty Streets at the crossing with the Western Maryland Railway. At the right is St. John's Catholic Church, still under construction, its steeple covered with boards. With the dirt streets, the railroad crossing is barely noticeable.

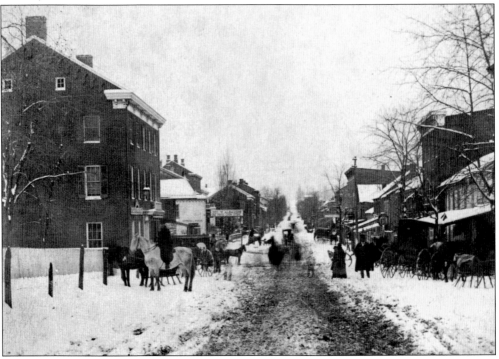

This rare stereograph from the early 1870s looks west along Main Street. The photographer was standing on East Main Street, approximately in front of St. John's Church. West Main Street disappears in the distance, rising up College Hill. Snow covers the sidewalks and the sides of the street, but traffic has churned the center of the street into a slushy mess, making driving and walking difficult.

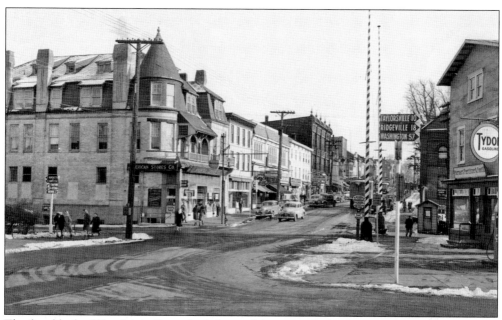

The first block of East Main Street had changed dramatically by the time this image was taken in 1950. The buildings east of the railroad crossing were built in the late 19th century and contained a variety of retail businesses. The old Albion Hotel on the corner had become home to the American Stores Company. Several neon store signs, including Carroll Pastry, American Restaurant, and the Centre Restaurant, dominated the streetscape in 1950.

This *c.* 1950 image shows the first block of West Main Street. The Rosenstock family constructed the large corner building in 1913 for their clothing store and a pool hall. G. C. Murphy 5¢ and 10¢ Store occupied the building from 1940 to 1980. At this time, the 1896 Babylon Building was home to Endicott-Johnson shoes and the City Restaurant. Beyond the Babylon Building was the A&P grocery store.

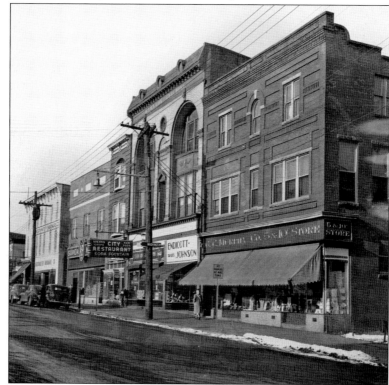

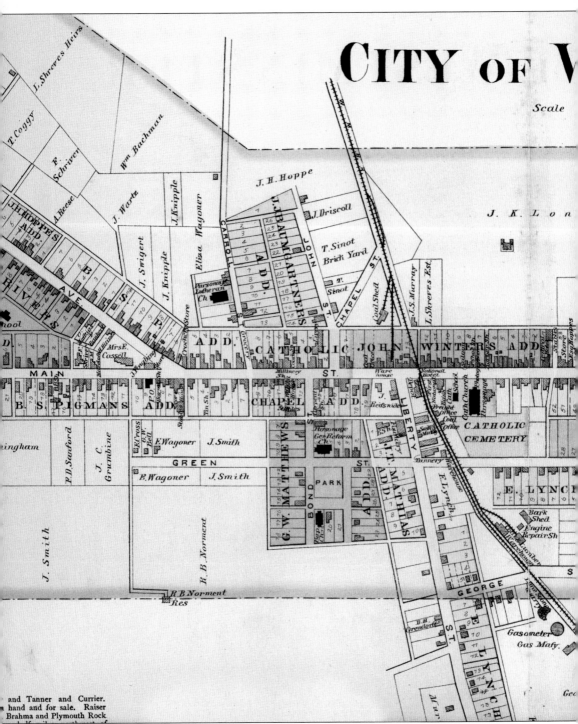

This map from the *Illustrated Atlas of Carroll County, Maryland,* published by Lake, Griffin and Stevenson in 1877, shows how rapidly Westminster grew in the years following the Civil War. William Winchester's original town is to the right along both sides of Main Street, below the courthouse and cemetery, and is labeled "Original Plat." Several additions had been annexed

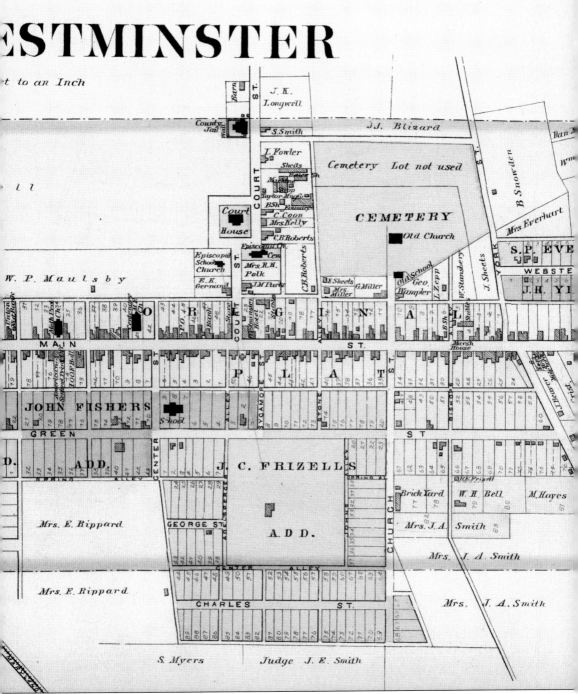

to the city and are identified on the map by the name of the original landowner. The Western Maryland Railroad tracks can be seen cutting through the center of town. Almost all the lots along Main Street were occupied and development was starting to spread out Pennsylvania Avenue. Westminster's population at this time was just over 2,300.

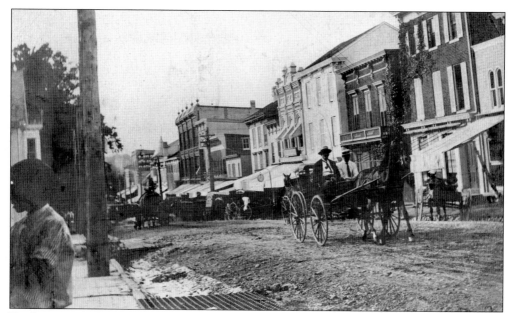

Further east on the first block of Main Street, large commercial buildings gave way to smaller stores and residences. Vehicles traveling on Westminster's unpaved streets raised a cloud of dust in dry weather and churned the streets into mud in wet weather. In this 1902 image, Henry Harbaugh drives east on Main Street, while behind him a sprinkler wagon dampens the dirt street to keep the dust down.

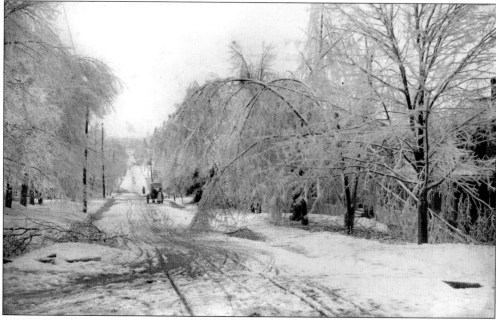

While there was extensive commercial development on Main Street, Green Street remained primarily a residential area lined with large trees and homes set back from the sidewalks. This image shows the damage on Green Street from what the *American Sentinel* called the "Great Sleet Storm" of February 21, 1902. Two inches of hail followed by heavy rains resulted in ice accumulating on trees and power lines.

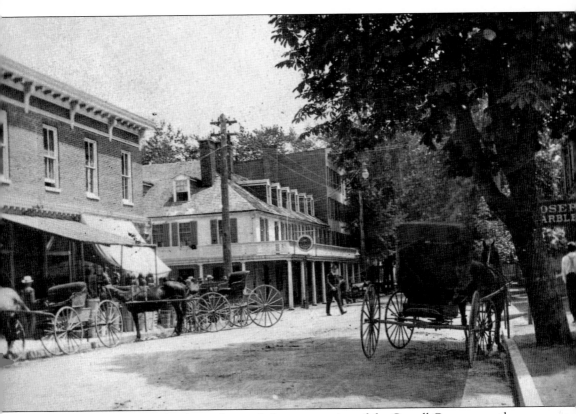

William Winchester's sale of town lots and the construction of the Carroll County courthouse encouraged early development along the east end of Main Street. A small commercial district developed at the intersection of Main and Court Streets. The building at the center of this image was built in the 1770s and was known over the years as Wheeler's Hotel, the City Hotel, and later, as the Main Court Inn. Jacob Reese constructed the large brick store at the left in 1854–1855. Visible at the right of this photograph (taken 1907–1909) is Joseph L. Mathias, Manufacturer and Dealer in Marble and Granite.

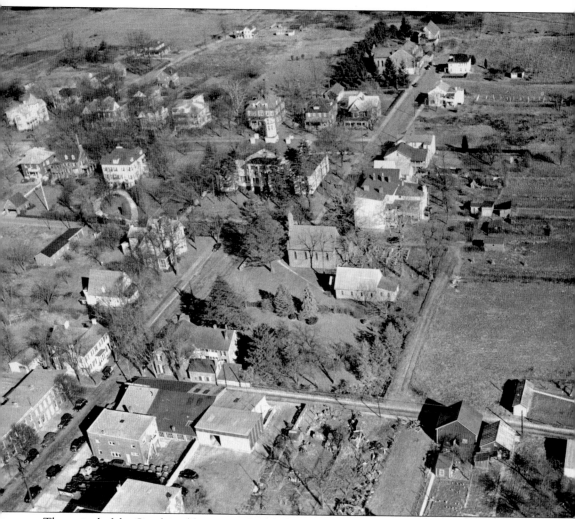

The arrival of the Goodyear blimp was a highlight of the Carroll County Centennial Celebration in 1937. Westminster resident Jesse C. Royer secured a ride and shot a series of photographs of the city from a perspective few would ever share. This image of the courthouse square reveals how much the city has grown. At the center of the frame, Court Street can be seen leading up to the courthouse. Just to the right front of the courthouse are the Church of the Ascension and its cemetery. The old jail is at the very top right. Not yet constructed are the courthouse annex, the Ascension Church parking lot and Holy Cross Hall, the new jail, and the county office building.

Two

Public Buildings

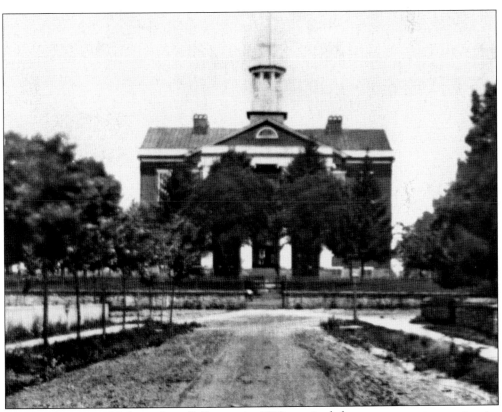

The legislation establishing Carroll County in 1837 required the new county to construct a courthouse. Isaac Shriver donated the land for the new courthouse, and Col. James M. Shellman designed the elegant Greek Revival building. A cupola and portico were added during the initial construction. This c. 1880 photograph shows the courthouse before the east and west wings were added in 1882. The wings were enlarged in 1935.

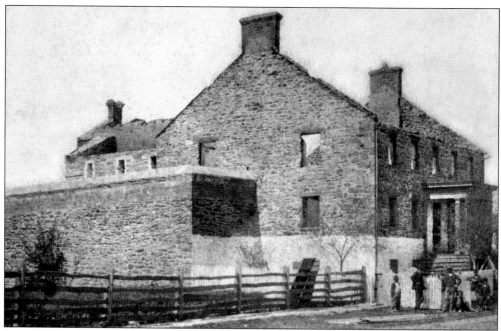

The jail, completed in 1837, housed prisoners and also served as the home for the sheriff and his family. A May 1882 fire, believed to have been set by prisoners, destroyed the roof and most of the interior of the building. This photograph of the fire damage is the earliest known image of the building. The jail was repaired and remained in use until 1971.

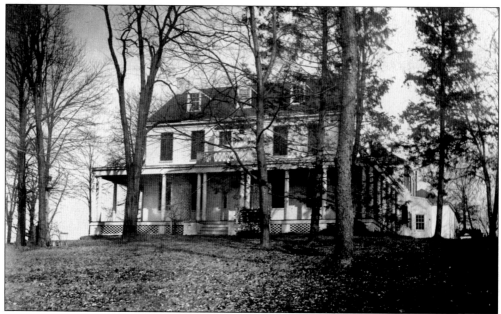

John K. Longwell moved to Westminster in 1833 to establish the *Carrolltonian and Baltimore and Frederick Advertiser* newspaper. In 1842, he built an elegant home called Emerald Hill. The house included mantels carved by Union Bridge native William Henry Rinehart. In 1908, after the death of Longwell's daughter, the house was sold at auction. The City of Westminster purchased the house in 1939 and opened it as city hall on August 17, 1942.

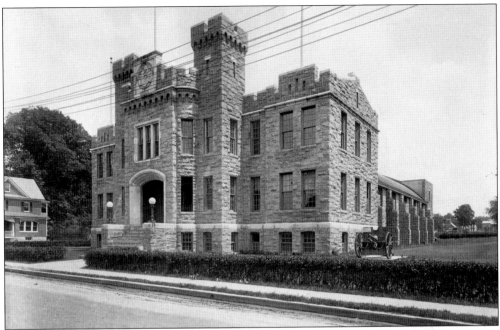

The National Guard Armory on Longwell Avenue was built in 1917, a reflection of the wave of patriotism that swept the nation following America's entry into World War I. Standing next to the building is a German artillery piece captured during the war at Chateau Thierry. The armory housed Company H of the Maryland National Guard.

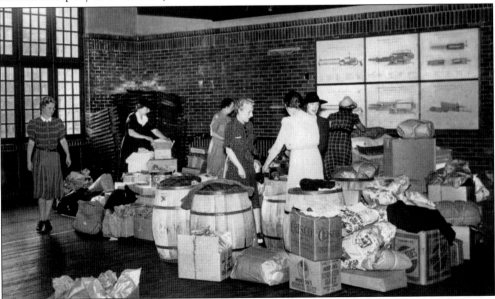

The armory became a center of community activities. Early in World War II, as England withstood Germany's aerial attacks, America began sending money and supplies to the British. The program expanded into Bundles for Britain, which collected used clothing and supplies for shipment overseas. As seen in this October 1940 image, locally donated items were taken to the armory, where volunteer members of the British War Relief Society of Carroll County sorted and packed them for shipment to Great Britain.

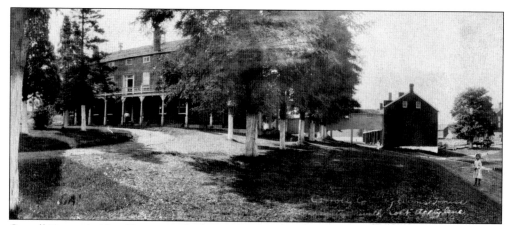

Carroll County's Alms House was the last of the three required public buildings to be constructed. Carroll County purchased 307 acres for the county farm. The dormitory-style main building, completed in 1852, was home to local inmates, the Alms House steward, and his family. A brick men's dormitory, connected by a covered frame walkway, was soon added. Other structures on the property supported agricultural activities. The Alms House closed in the 1960s and is today the Carroll County Farm Museum.

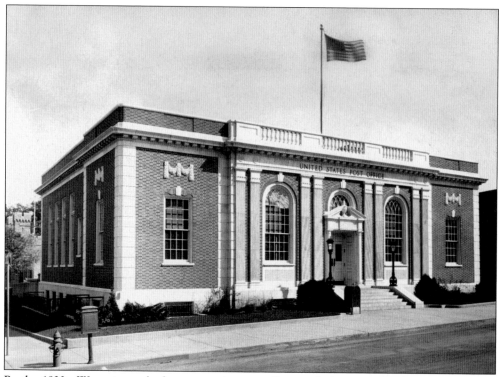

By the 1930s, Westminster had outgrown its post office, and plans were made for a large, new facility at the corner of Main Street and Longwell Avenue. Construction began in early 1932, the cornerstone was laid on November 30, and the new building opened in August 1934. The building was expanded over the years before being replaced by a larger facility.

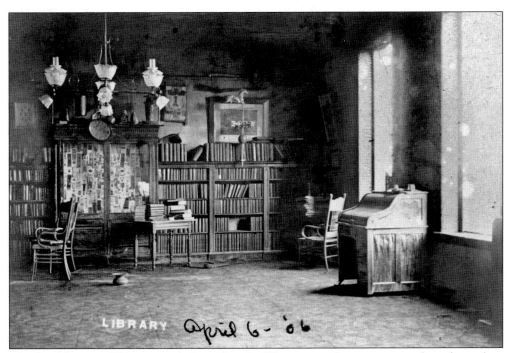

LIBRARY *april 6 - '06*

The first library in Westminster belonged to the Westminster fire company and was housed on the second floor of their headquarters on East Main Street. The collection included reports issued by many federal government agencies as well as popular literature donated by local residents.

In 1949, W. H. Davis announced the donation of a library for Westminster. He established a board of trustees to oversee the library and purchased the old Methodist Protestant Church building at 129 East Main Street. After extensive renovations to the building, including the addition of a marble facade, the Davis Library was dedicated on May 27, 1951. In 1958, the commissioners of Carroll County accepted control of the library, which formed the foundation for the Carroll County Public Library.

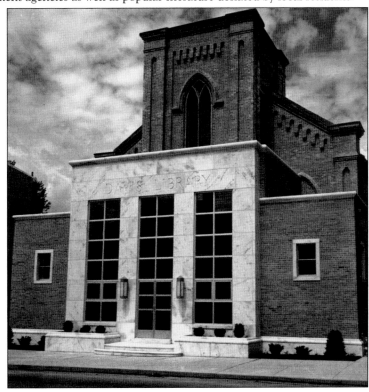

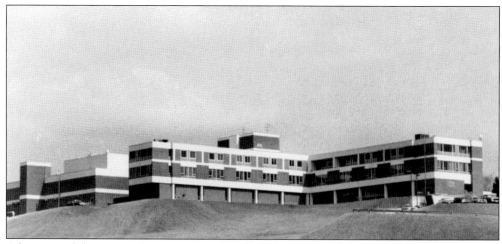

After years of planning and construction, Carroll County General Hospital (above) was dedicated on August 27, 1961. A committee of local businessmen and members of the Carroll County Medical Society began planning the hospital in 1957, and construction began in 1960. Braving the heat and humidity, 1,500 people attended the opening festivities, which included remarks by former governor Theodore McKeldin. During the ceremonies, pictured below, Homer Y. Myers (right), president of the project's general contractor, Stuller Construction Company, presented the key to the building to Atlee W. Wampler, president of the board of directors. The *Carroll County Times* described the 52-bed facility as "ultra-modern," with amenities such as air-conditioning and fire retardant drapes on the windows. Now known as Carroll Hospital Center, the facility has expanded to over 200 beds and has 400 physicians on staff.

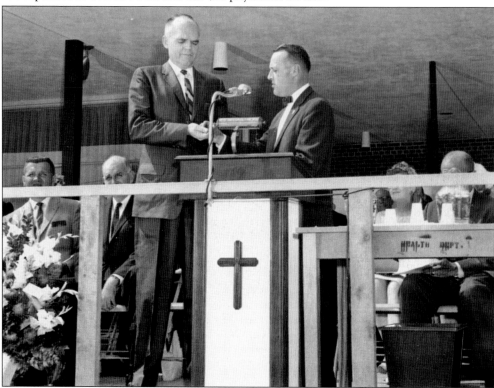

Three

BUSINESSES

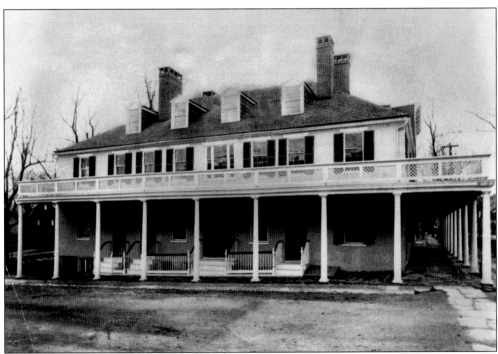

One of the earliest buildings in Westminster was the tavern at East Main and Court Streets, built *c.* 1770 to accommodate stagecoach travelers. The business was known at various times as Dymock's, the City Hotel, and the Main Court Inn. In 1863, the hotel served as a temporary hospital for those wounded at Gettysburg, including Col. Paul J. Revere, grandson of Revolutionary War patriot Paul Revere, who died here on July 4. The building fell on hard times in the 20th century and was demolished in 1940.

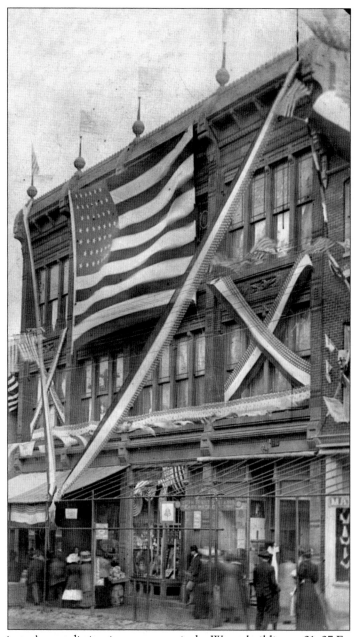

One of Westminster's most distinctive structures is the Wantz building at 21–27 East Main Street. Westminster businessman Charles Valentine Wantz built the two eastern sections in 1882 to house his growing cigar manufacturing business. Later he doubled the building's size, adding the two western sections in 1890. According to family legend, Wantz intended to construct only a two-story building, but he added the third floor as a meeting room for the Masons, a group to which he belonged. Over the years, the building housed a number of businesses, including the Chesapeake and Potomac telephone exchange, Sharrer Brothers (tailors and purveyors of ready-made clothes), and Sharrer and Gorsuch (men's clothing and furnishings). The city council chambers were on the second floor before moving across the street to the new firehouse. This photograph dates to May 1910.

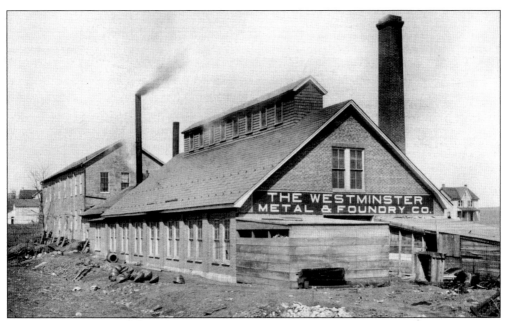

The Westminster Metal and Foundry Company, established in 1910, specialized in refining waste metals into useable brass, bronze, and white metal. The plant opened in two small buildings at the foot of John Street, as seen in this photograph. The company grew quickly and, by 1914, employed nearly 100 men. The physical plant had expanded to include a chemical lab, brass foundry, iron foundry, pattern shop, and drafting department.

In 1894, Harry Harbaugh opened the Palace Livery Stable on Main Street next to the firehouse. On April 6, 1906, fire roared through the stable, killing several horses and leaving Harbaugh's family homeless. Harbaugh rebuilt, and by 1920, he had moved with the times, selling Dodge and Hudson cars at the Palace Garage. Not surprisingly, Harbaugh advertised that he ran a fireproof garage.

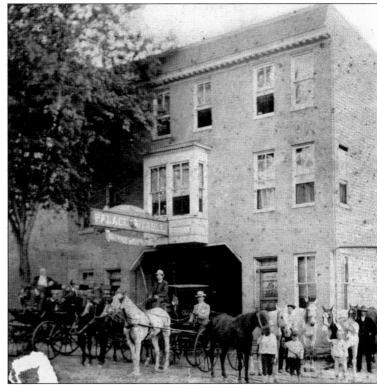

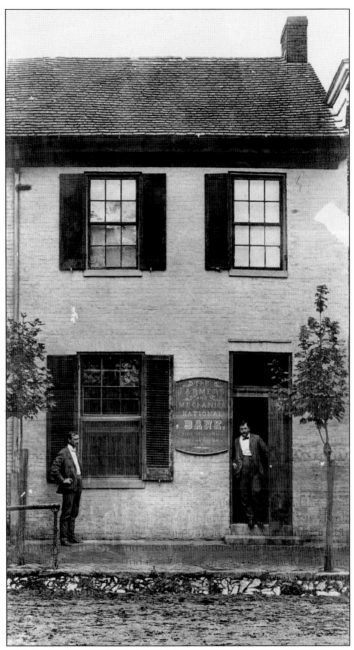

The Farmers and Mechanics Bank of Carroll County was chartered by the State of Maryland in 1850. Jacob Mathias was the bank's first president and Jacob Reese the first cashier. Among those on the board of directors were William Bachman, David Cassell, John Roop, David H. Shriver, Sterling Galt, Joshua C. Gist, and John Brooke Boyle. One of the board's first acts was the purchase of a lot on East Main Street for the construction of a bank. Local contractor Wampler and Evans constructed the building, which was completed in January 1851. In 1865, the bank changed its name to the Farmers and Mechanics National Bank of Westminster. The original bank building remained in use until August 1900, when it was torn down for the construction of a larger facility.

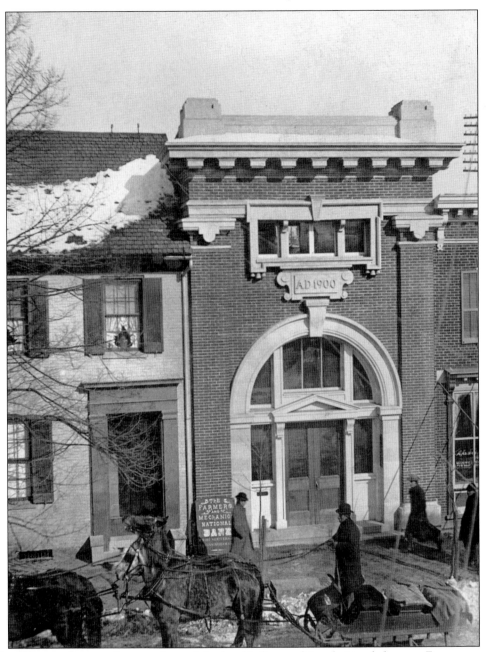

Paul Reese, who was the grandson of the bank's first cashier, designed the new Farmers and Mechanics Bank, seen here shortly after its completion in 1900. Reese, who was born in Westminster, was the son of a professor at Western Maryland College and is considered Westminster's first professional architect. Reese's design for the bank stood out from the other buildings on Main Street, as he attempted to introduce design elements from the Beaux-Arts style popular in Europe. The building apparently proved too small for the bank's needs because the company moved next door to a new, larger building in 1917. Reese later designed the Westminster Theological Seminary and some of the barracks at Pearl Harbor that were destroyed on December 7, 1941. Late in life, Reese became a minister in the Protestant Episcopal Church and moved to Texas.

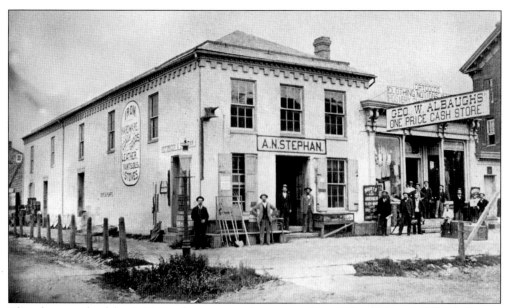

This photograph of the A. N. Stephan store at the intersection of West Main and Liberty Streets was taken in summer 1880. The store's merchandise included iron, hardware, coach goods, leather, paints, and stoves. From left to right are Tom Babylon, Harry Reese, Albie Duvall, A.N. Stephan, F. R. Buell, Clinton Spurrier, B. F. Weishample, unidentified, James Alexander, William H. Bixler, Fred D. Miller, Chester Weishample (boy on box), Milton Senft, and George W. Albaugh.

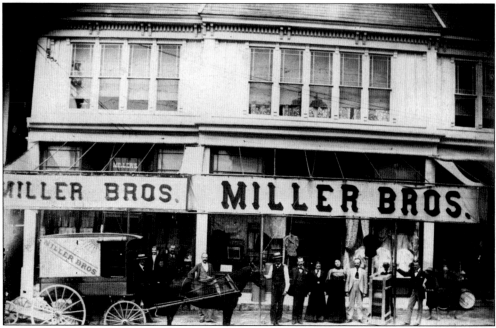

In 1887, Fred D. and Frank Z. Miller opened Miller Brothers clothing store in a room at 9 East Main Street. The brothers were born in Indiana, but they had moved to Westminster to live with their grandmother after the deaths of their parents. The business was so successful that in 1894, the brothers expanded the store, seen here, to include the former Kann store at 11 and 13 East Main Street.

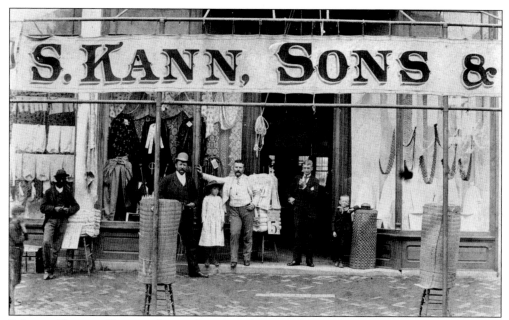

Solomon Kann and his sons Lewis, Simon, and Sigmund opened S. Kann, Sons & Company at 11 East Main Street as a branch of their successful Baltimore operation. Kann's advertisement in the 1887 Westminster business directory described the Westminster store as a "mammoth establishment." In 1894, Kann's closed its Westminster operation and sold all its remaining goods to a new company owned by M. Schneeberger.

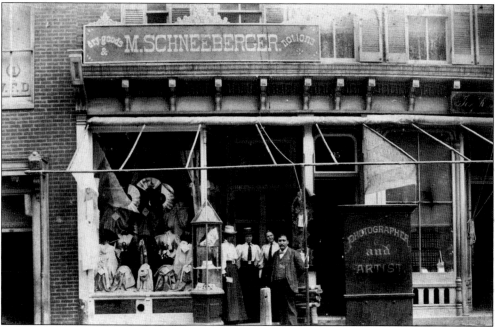

M. Schneeberger's dry goods store opened in the Albaugh building at 33 East Main Street in 1894. Scheeberger opened his store after buying the remaining inventory when S. Kann, Sons & Company closed its doors. This image from the late 1890s shows Mr. Schneeberger and his employees in front of the store.

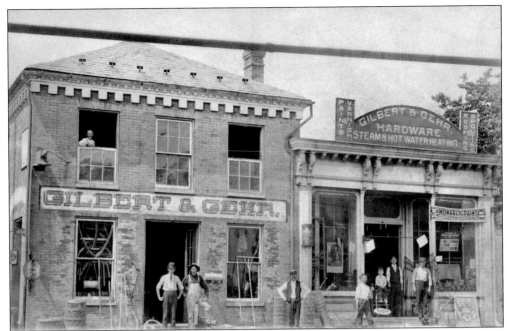

In 1886, F. Thomas Babylon and Oscar D. Gilbert purchased A. N. Stephan's store after Stephan's death and renamed the business Babylon & Gilbert. In 1895, Babylon sold his interest to Denton S. Gehr, and the company became Gilbert & Gehr. This *c.* 1900 image shows the store at the corner of Main and Liberty Streets, which included a salesroom and warehouses in the rear.

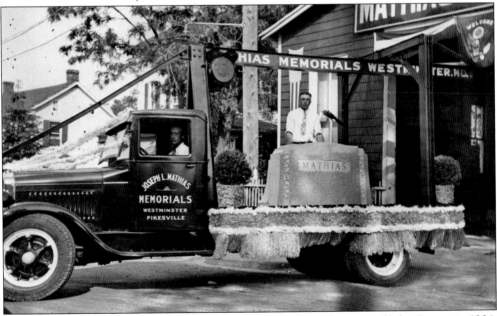

Joseph L. Mathias Sr. purchased the tombstone and monument business of John Beaver in 1904. At that time, the firm was located at 124–126 East Main Street. In 1910, Mathias moved the business to larger quarters at 192–194 East Main Street. The company moved to the corner of Main and Center Streets in 1952. This image of the delivery truck decorated for a parade was taken *c.* 1940.

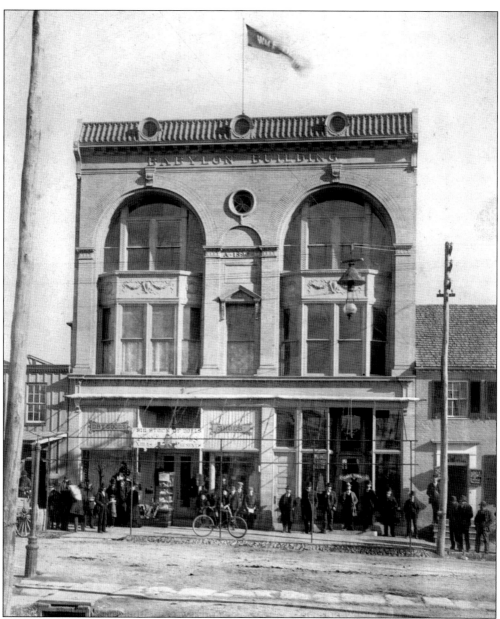

F. Thomas Babylon began his retail career as a clerk at A. N. Stephan's store. He and partner Oscar D. Gilbert bought the business after Stephan's death in 1886 and changed the name to Babylon & Gilbert. In 1895, Babylon sold his interest in Babylon & Gilbert to Denton S. Gehr, and went into partnership with George W. Albaugh. The result was the Albaugh & Babylon Grocery Company. Babylon, as president of the firm, purchased the lot at 12 West Main Street from Jacob Wilson in 1895 for $5,000. The following year, the business constructed a large two-story building with distinctive arched windows. Described by the *American Sentinel* as an example of the structures built by merchants as "monuments to the eternal progress of mankind," the Babylon Building overshadowed the small, early buildings in the block. This image was taken shortly after the building's construction, before the smaller flanking buildings were replaced in the early 1900s.

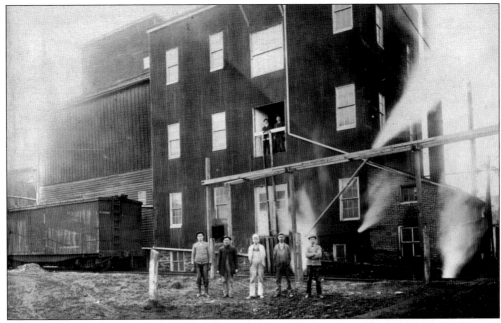

In 1861, Samuel Cover and J. Henry Hoppe built a warehouse on Main Street beside the new Western Maryland Railroad tracks in order to store and ship grain to Baltimore. After several changes in ownership, Nathan I. and Charles C. Gorsuch acquired the property and renamed the firm N. I. Gorsuch and Son in 1881. In 1885, they constructed a grain elevator with the capacity to store 25,000 bushels of grain. A plant for packing straw and hay was completed in 1888. In 1890, a flour mill capable of producing 160 barrels per day was added. The photograph above shows the mill complex on January 27, 1913. The mill also had a retail store in the warehouse (below), which sold fertilizer, potatoes, flour, canned goods, soap, and other supplies.

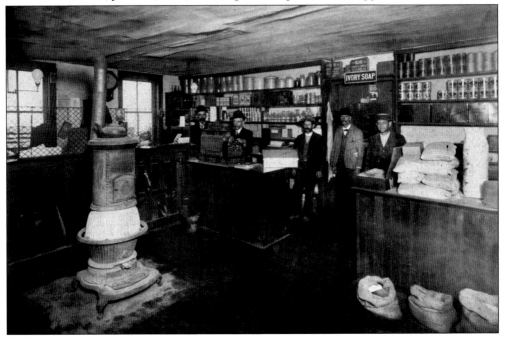

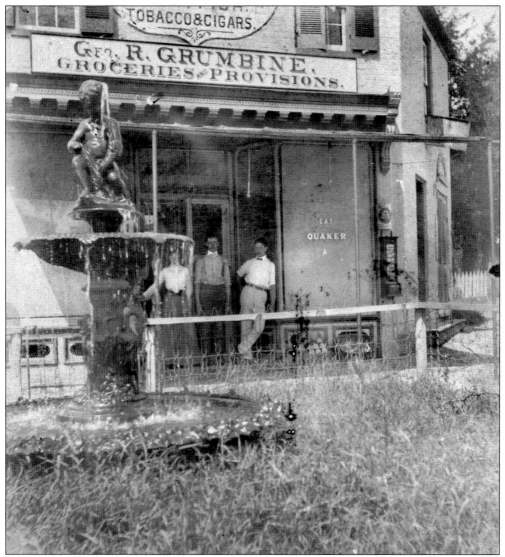

In the early 19th century, a turnpike was built from Baltimore to Chambersburg. The road ran through Westminster to the western edge of town before turning northward. Soon after, a road west was completed from Westminster to Taneytown and then on to Emmitsburg. These two roads met at an odd angle that became known as the Forks. Heavy traffic on these two main roads made the Forks a prime location for stores, hotels, and offices. In 1892, George and Frank Grumbine bought the grocery store operated by Ezra Zepp at the Forks. George Grumbine became the sole proprietor in 1894. In 1910, the *Democratic Advocate* reported that Grumbine sold "fancy and staple groceries and a splendid assortment of candies and confections, both plain and fancy" and that "country produce is accepted in trade at the highest market prices." To attract attention and potential customers, Grumbine decorated the yard in front of his store with an elaborate fountain.

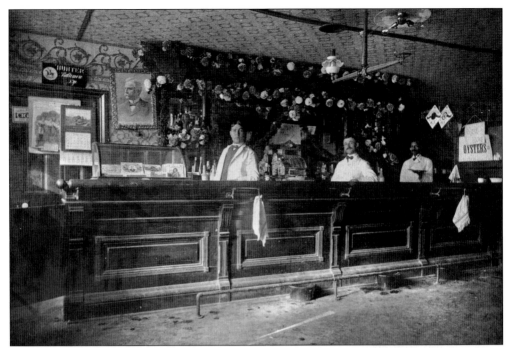

Saloons were located throughout Westminster for the convenience of local residents and visitors. Seen in this *c.* 1900 image is Weikert's Saloon. The interior decor included a decorative ceiling, gas lamps, and flowers behind the bar but also spittoons on the floor in front of the bar.

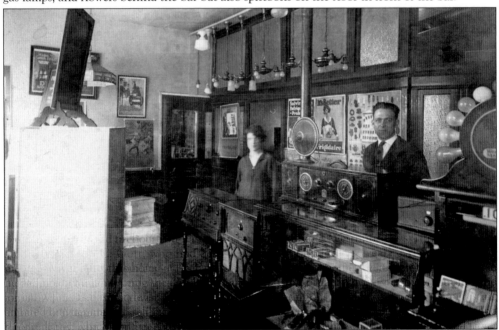

Frounfelters sold home appliances, including radios, phonographs, and lights, but refrigerators seemed to be their most important product line. This image shows G. E. Miller in the store on Liberty Street in the early 1920s. The store was on Main Street for a few years before moving to East Green Street.

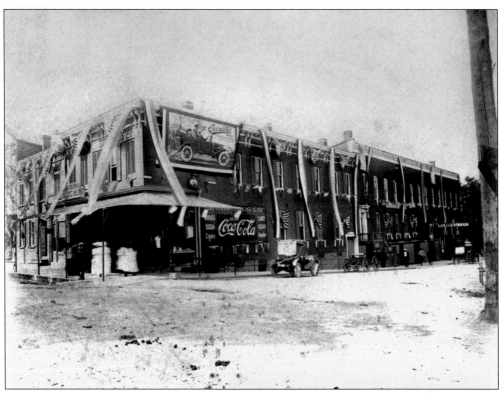

At 46 West Main Street, at the
intersection with John Street, stood
Shaw's drugstore (above). Sharing the
building on Main Street was Thomas
H. Easley's clothing store. At the far
end of the block along John Street
stood Wilson's Livery Stable. After
Shaw's death in 1923, Ralph Bonsack
took over the drugstore and operated
it for many years. Below is an interior
view of Shaw's drugstore, with Victor
Lynch manning the soda fountain.
(Above, courtesy of Paul Wardenfelt.)

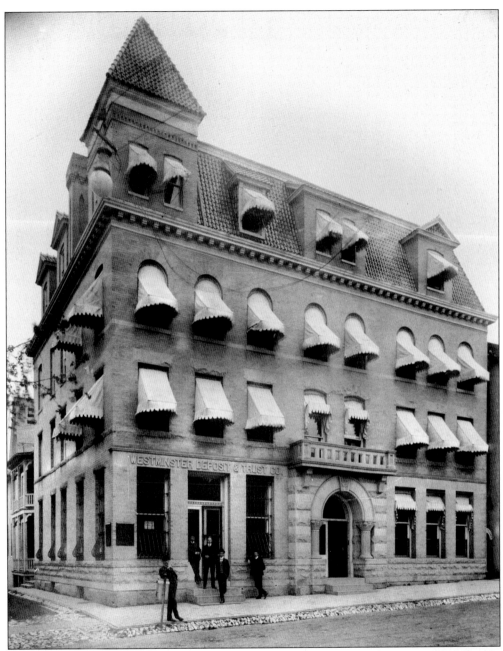

At 117 East Main Street stands the Charles Carroll Hotel. Built in 1898 by George W. Albaugh, the hotel stands out from other buildings in the city for both its massive size and its distinctive architecture. A square tower and Spanish tile roof top its yellow brick walls, and its main entrance is flanked by Corinthian columns (the capitals decorated with carved lions) that support a large rounded arch. Guests marveled at the electric lights, elevators, and porcelain baths, and the *Democratic Advocate* proclaimed the hotel "unsurpassed in general merit by any building of the kind elsewhere." Part of the ground floor housed the Westminster Deposit and Trust Company. The building would later be known as the Westminster Hotel. Though the hotel closed, the building remains a bank.

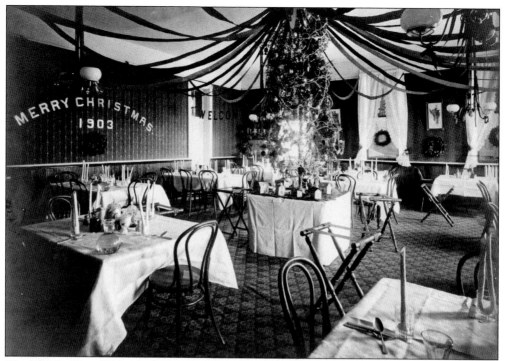

The Charles Carroll Hotel was famous for its amenities. This image shows the hotel dining room, located at the rear of the building, decorated for Christmas in 1903.

George W. Albaugh and F. Thomas Babylon founded the Albaugh & Babylon Grocery Company in 1896. This *c.* 1910 image shows the interior of the store at 13 East Main Street. From left to right are John Case, Ralph Royer, Adam C. Corbin, Cletus Little, Paul Bixler, Paul Wimert, and Simon Nusbaum.

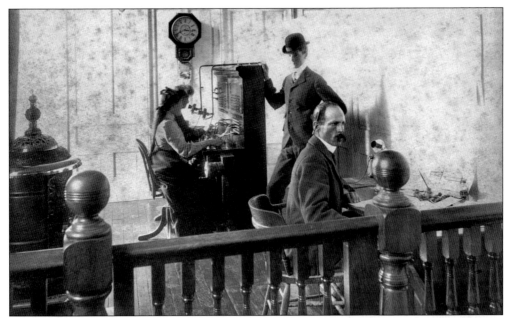

The first telephone switchboard in Westminster was in the Shellman house at 206 East Main Street, home of telephone operator Mary B. Shellman. By the time this image was taken in 1902–1903, the telephone exchange office was on the second floor of the Wantz building. Seated on the right is manger John Knode and standing on the right is night operator Harry Starr. The women are unidentified.

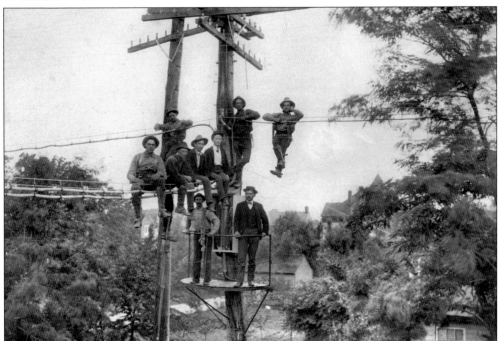

A group of telephone employees posed for this image in an alley off East Main Street. On the platform are Corky Yingling (left) and Frank Myers. Among those seated are Charlie ?, Charlie Brown, and Guy Fringer Jr. The men standing are unidentified.

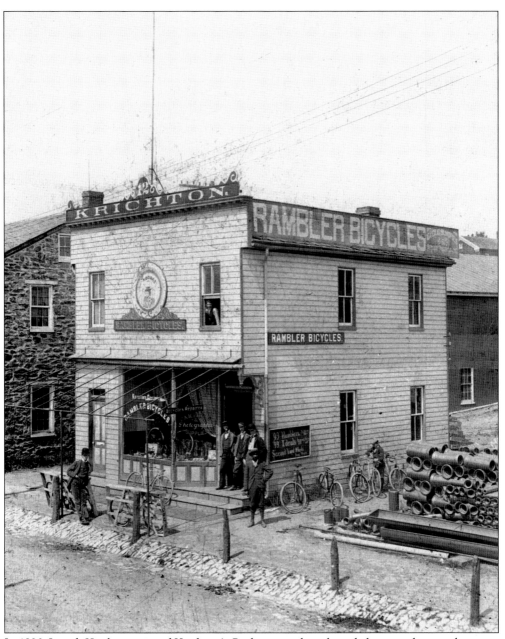

In 1890, Joseph Krichton opened Krichton's Cyclorama, a bicycle and photographic supplies store at 12 Liberty Street near the intersection of Liberty and West Main Streets. This image shows the store that was decorated with advertisements for the new 1899 models of Rambler bicycles, a number of which are visible in the image. Krichton's two businesses went hand in hand, since taking amateur photographs was a popular hobby for many early cyclists who frequently made day trips through the countryside. The rural scenery provided many opportunities to take snapshots that served as mementos of the journey. Krichton sold the bicycle shop to Joseph Shreeve in 1901. In addition to selling photography supplies, Krichton operated a photography studio from 1889 to 1903. The corner of the stone cannery of the B. F. Shriver Company is visible to the left of Krichton's.

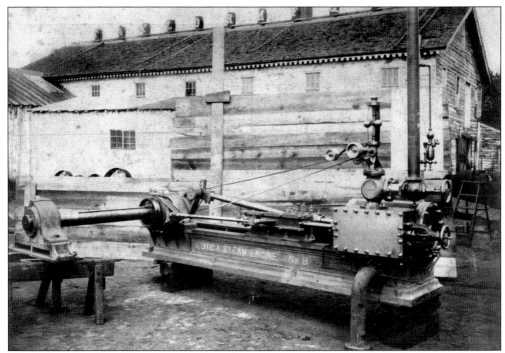

The Taylor Manufacturing Company, established by George and Edward Taylor, was on Court Street near the jail. Its main products were stationary and portable steam engines but also included boilers and mill machinery. The company employed 65 men in January 1880, but by August 1881, the work force had grown to 102. The 1880 *Maryland Directory* noted the firm did "a large business in the manufacturing of vertical, horizontal and stationary engines, which are in demand in all parts of the country, from Maine to Texas." The *c.* 1880 photograph above shows the factory with its name spelled out in fire barrels along the roof ridge. Below two of the employees are posed with a 40-horsepower engine and boiler outside the plant. By 1884, the firm had moved to Chambersburg and leased the Westminster plant to a company that manufactured windmills.

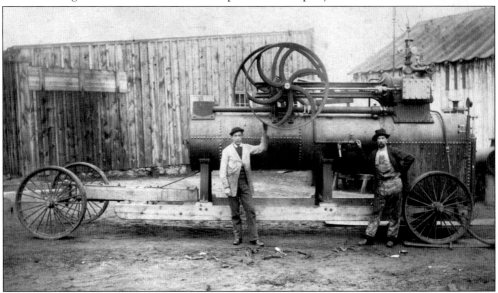

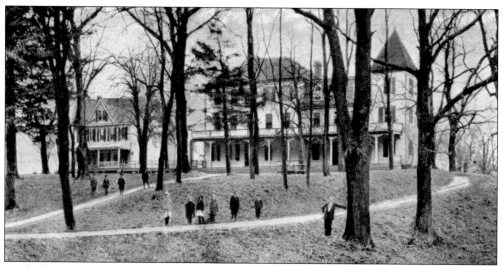

By the late 19th century, hotels and resorts thrived throughout Carroll County as Baltimore residents fled the city's summer heat. Winchester Place (above) was constructed c. 1800 by one of William Winchester's descendents, probably his son David. The house stood on a hilltop on a 10-acre site just south of what is now East Green Street. By the 1880s, the house had been greatly enlarged for use as a resort. The resort's accommodations included cottages, a dance hall, croquet grounds, and tennis courts. Local residents also patronized Winchester Place, attending fancy balls or dinners and picnicking on the grounds. James S. Baer Jr. took this photograph (below) of members of Westminster's Methodist Protestant Church at the old spring at Winchester Place on July 1, 1897. Clockwise from top are Will Mather, Lilly Woodward, Mary B. Shellman, and Nan Rinker.

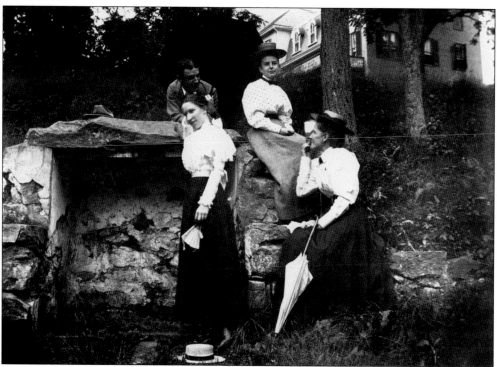

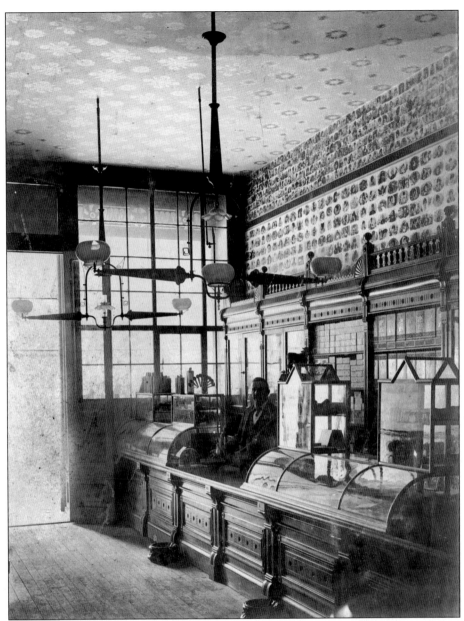

Charles V. Wantz opened a cigar manufacturing business in Westminster in 1876. Soon the business was so successful that he moved the operation to a larger space in the Wantz building at 25 East Main Street. At that time, Wantz opened a retail store specializing in his own brands of cigars but also carrying tobaccos, cigarettes, and imported cigars. This image shows the interior of what *Tobacco* magazine described in September 1896 as "a novel Maryland Store." After describing the cases and counters, the magazine also noted, "the novel part of the decorations, the walls being actually papered with cigar labels, neatly and artistically arranged by expert workmen." It took Wantz over five years to acquire the 8,000 labels, which were samples sent out by printers, and took two men three days to install them. One of Wantz' other unique marketing ideas was to give an imported breech-loading shotgun to each customer who purchased 1,000 cigars. Over the years, he gave away 5,000 shotguns, indicating sales of over five million cigars.

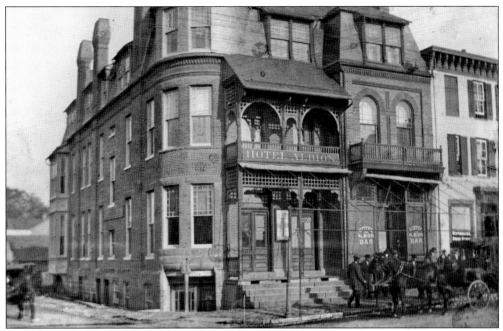

In May 1886, William B. Thomas and Elias Grimes purchased the old National Hotel at 1 East Main Street, directly across the street from the railroad passenger station, and hired Baltimore architect Jackson C. Gott to design a new, larger hotel. The result was the Hotel Albion, a Queen Anne–style structure noted for its massive round tower and tall chimneys.

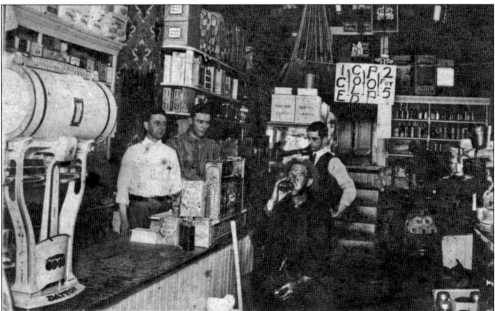

William N. Keefer was only 19 years old when he became the owner of a grocery store at 86 East Main Street. Keefer's father owned the building, and when the tenant closed his store due to illness, Keefer bought the stock and set his son up in business. In this photograph taken soon after the store opened in 1894, from left to right are William N. Keefer, Francis Keefer, Edwin Zahn, and a man with the surname Seboure.

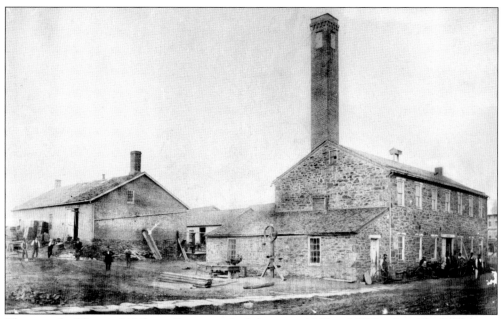

The stone building at 14 Liberty Street was built between 1867 and 1870, when Elijah Wagoner and George Matthews operated a machine shop and foundry there. In 1875, Wagoner bought out Matthews's interest in the business. Unfortunately Wagoner's creditors foreclosed on the property in 1878. The B. F. Shriver Canning Company bought the building in 1881 and operated there for about 20 years. This image dates to the early 1870s.

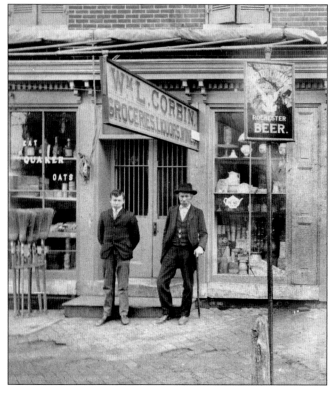

William L. Corbin operated a grocery store on East Main Street near the railroad station in the late 1800s. The store also sold liquor, wines, and Rochester brand beer. Working with Corbin was his son Oden, who went on to establish his own store at the corner of Main and Court Streets in 1912.

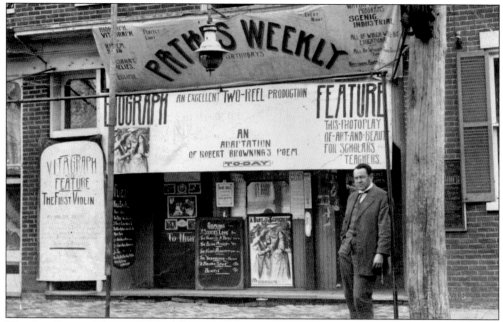

The Star Picture Theater, one of the earliest in Westminster, stood near the corner of Main and John Streets and shared a building with Shaw's drugstore. Theater manager George Osborne posed outside the business in this 1908 image. The Star was demolished in 1923 to make way for the construction of a new theater.

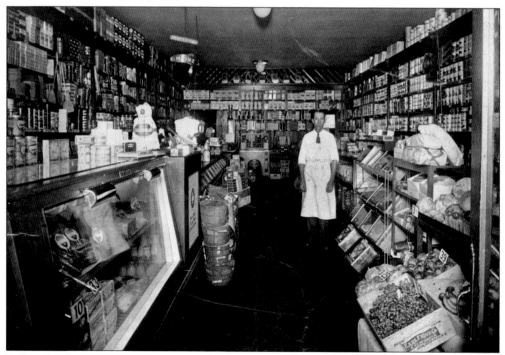

Robert Snyder's grocery store stood at 290 East Main Street, far from the main commercial district, and served those who lived in the area near the store. Snyder, who had taken over the business from Billy Reese, posed for this picture on September 15, 1932.

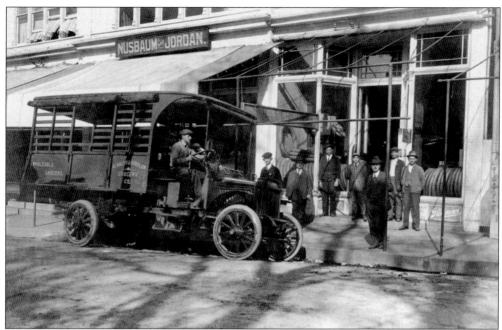

Albaugh & Babylon Grocery Company employees Charles Kresel, Paul Bixler, F. T. Babylon, Joseph Stisson, Sellman Bechl, Nicholas Hill, Carroll Albaugh, C. C. Little, and Charles Null posed proudly with their new Atterbury delivery truck on Main Street in this *c.* 1915 image. The truck was the firm's first motorized delivery vehicle and reputedly the first in Westminster.

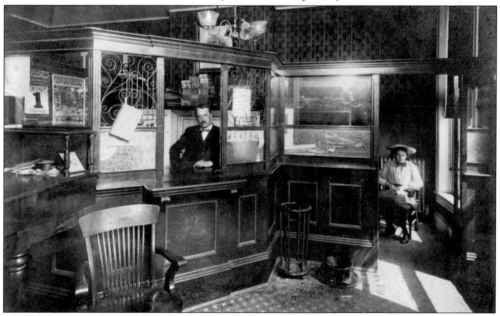

The Westminster Deposit and Trust Company opened for business on July 5, 1898, in temporary quarters on Court Street. The following year, it moved to its permanent home on the first floor of the Charles Carroll Hotel at 117 East Main Street. Bank employee Ezra Stem posed behind the teller counter, and his daughter Marguerite was in the office for this *c.* 1900 photograph. The bank moved to 71 East Main Street in 1952.

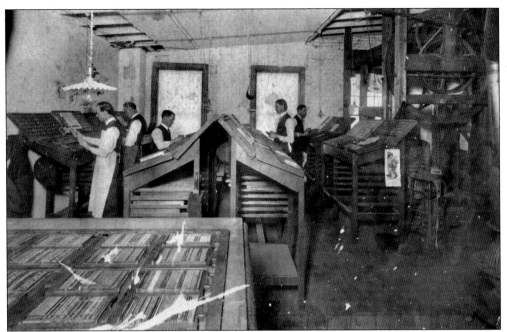

The first issue of the *American Sentinel* appeared June 15, 1855, as the successor to the *Westminster Carrolltonian*. The paper was a staunch supporter of the American party, and later, the Republican party. This late-1800s image shows the *Sentinel*'s print shop. The paper ceased operations in 1928.

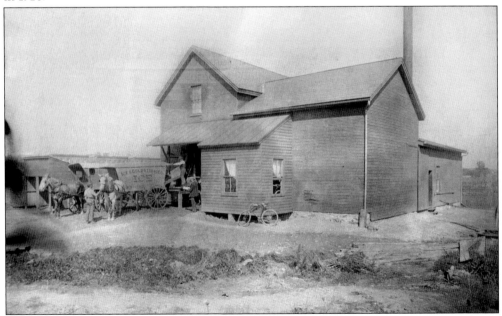

In the early years of the 20th century, ice cut from natural sources such as ponds and lakes began to be replaced by manufactured ice. The Ice & Cold Storage Company of Westminster, located on Gorsuch Road, manufactured ice in blocks in large molds. This photograph was taken by Philadelphia photographer James. L. Dillon, whose studio was in business between 1893 and 1922.

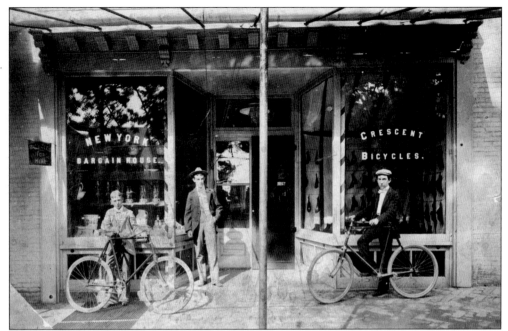

The New York Bargain House at 34 East Main Street offered a wide assortment of merchandise at discount prices. Advertisements for the store in 1897 included books, women's and children's shoes, garden trowels, meat saws, and secondhand bicycles. The firm also rented bicycles—men's, ladies', and tandems—by the hour, day, week, or month.

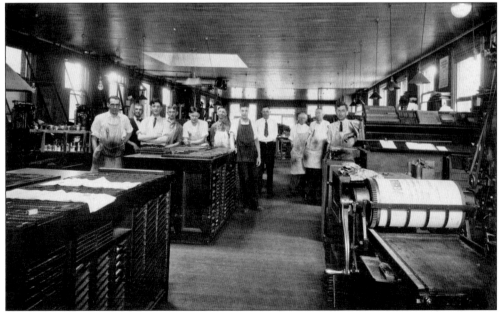

The Mather Printing Company released the first issue of the *Times* on October 6, 1911. This *c.* 1930 image shows the *Times* printing plant and, from left to right, employees Oscar Bair, William Sullivan, George Fringer, Ralph Royer, Harry Crumpacker, David Witter, John Fringer, Claude Kimmey, Ross Galt, Gay Fowler, and Edgar Royer. The paper became known as the *Carroll County Times* in 1956.

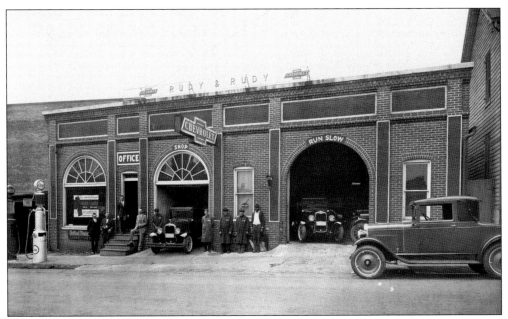

As automobiles became more widespread in the early 20th century, new businesses opened to sell and care for them. The 1932 Westminster telephone directory listed 16 car dealerships. Rudy and Rudy was located at 31 West Green Street in 1927 and had moved to 14 Liberty Street by 1932. The company may have gone out of business at that time, since it does not appear in telephone directories after that year.

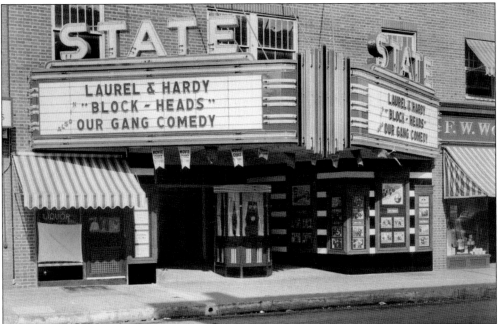

The State Theater was constructed in 1923 on the site of the old Star Theater at the corner of Main and John Streets. Walter H. Davis purchased the old theater and began work on what the *Democratic Advocate* called an "up-to-date theater." The Laurel and Hardy movie advertised on the marquee in this image was released in 1938. (Courtesy of Paul Wardenfelt.)

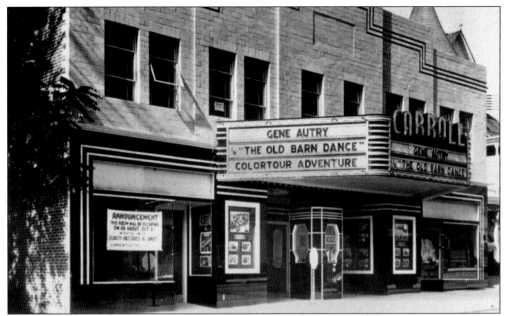

When Westminster's new Carroll Theater opened on Thanksgiving Day, November 24, 1937, all 850 seats were filled. Art deco in style, the theater's exterior was finished in yellow tile brick and black carrara glass. The *Democratic Advocate* raved that the theater was "in all respects the most completely modern building in this city." The Gene Autry movie advertised on the marquee in this image was released in 1938. (Courtesy of Paul Wardenfelt.)

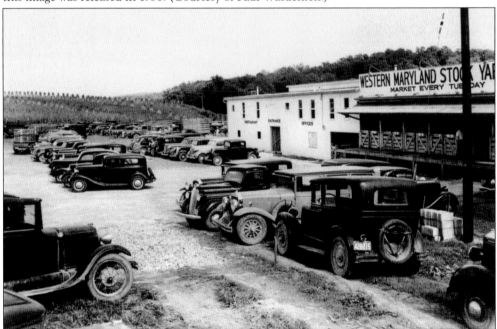

The Western Maryland Stockyards, located a few blocks from Main Street at the end of John Street (extended), opened for business September 13, 1938. According to the *Carroll County Times*, the buildings were "large and spacious, entirely under cover, and have every convenience for stockmen and their cattle." The stockyards held sales every Tuesday. (Courtesy of Paul Wardenfelt.)

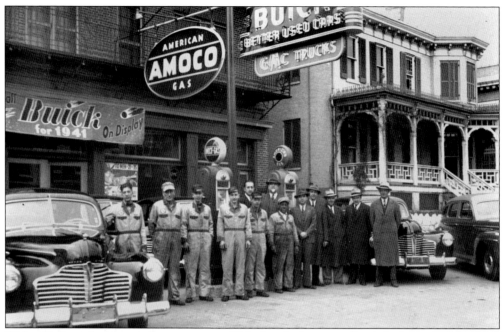

Walter H. Davis had been selling cars since 1910 when he became a Buick dealer in 1920. In 1930, the company moved from John Street to a more prominent location at 31 West Main Street. The front of the first floor housed the showroom, with service bays in the rear. This image shows the launch of the new 1941 models.

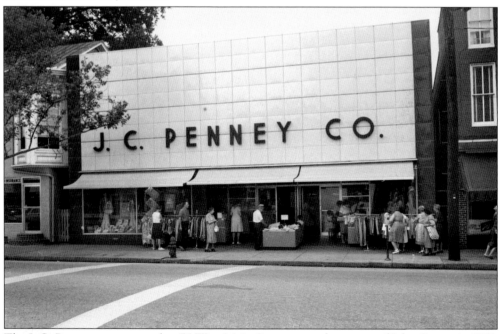

The J. C. Penney store opened at 56 West Main Street, near the corner of John Street, in 1929. The store had a more modern look than most of the other buildings in town, with the front of the building faced with large, square white tiles with the company's name in green letters. This photograph by John Byers shows a sidewalk sale in the 1950s.

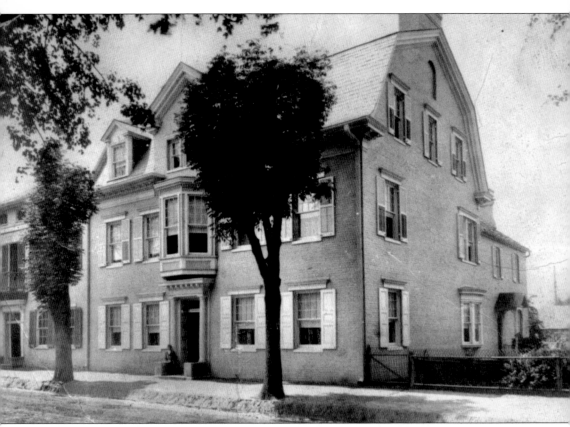

The exact date of construction of the building at 216 East Main Street is not known. By the 1830s, Joshua Cockey was operating it as a hotel. By 1835, Cockey had left Westminster and appointed John Fisher to handle the property, either selling or renting it. Fisher controlled the property until 1862, when he sold it to the Bank of Westminster. During Fisher's tenure, the building continued to operate as a hotel or boardinghouse. John Brooke Boyle purchased Cockey's from the Bank of Westminster in 1872 as a residence for his family. He sold the building to his daughter Elizabeth and her husband, Charles E. Fink, in 1893. The Finks renovated the house, adding the gambrel roof, bay windows on the front and side, and marble front stoop with columns seen in this image. In 1922, Frank and Mary Hoffman bought the building and opened Hoffman's Inn. Their daughter Thelma continued operating the boardinghouse and restaurant until 1969. Various owners ran the restaurant known as Cockey's Tavern until 2000. The Historical Society of Carroll County now owns the property.

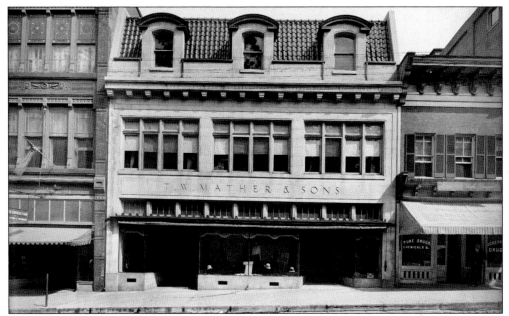

Thomas W. Mather Sr. opened a small store at the corner of West Main and John Streets in 1890. In 1897, the firm became T. W. Mather & Sons and moved to 31 East Main Street. The store expanded in 1902, tripling the floor space by adding a third floor and basement. In 1954, the Parsons Company bought the store but continued to operate under the Mathers name. Mathers closed in 1996.

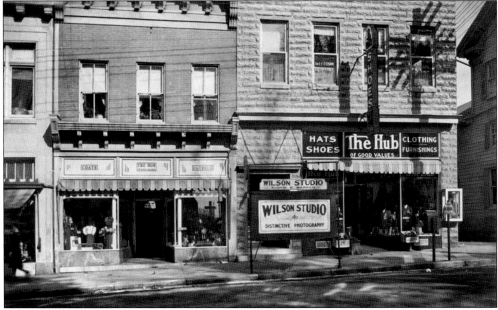

The Hub (of Good Values) clothing store moved to 37–41 East Main Street in 1935. Photographer Sereck Wilson located his studio on the second floor of the building. The unusual stone structure was built c. 1885 as Westminster's post office during the tenure of postmaster Joseph B. Boyle. Ironically the Hub's old location had been a block away, adjacent to the new post office. (Courtesy of Paul Wardenfelt.)

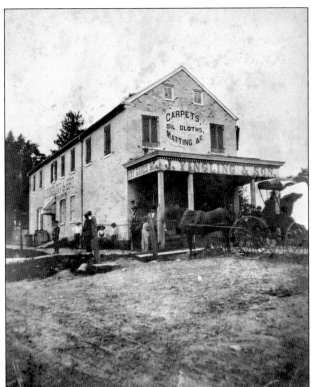

At the close of the Civil War, Horatio Price and Alfred Troxell built a two-story brick store in the angle at the Forks. Within a few years they retired, and Joshua Yingling took over the business. The store featured flooring materials, including carpets, matting, and oilcloths. After Yingling's death, Ezra and Jesse Zepp acquired the building for a grocery store. Later George Grumbine's grocery store would occupy the building.

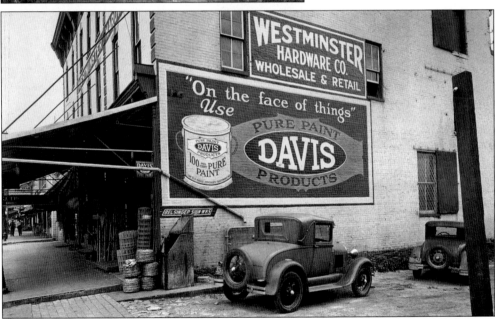

The Westminster Hardware Company was founded in 1898, taking over M. Schaefer and Company, which had been established in 1877. The new business increased its retail space and added a wholesale department with a traveling salesman. The store sold various goods, including hardware and housewares, and served school systems, roofers, and contractors. This 1931 image shows the store at 18 West Main Street.

Four

HOUSES

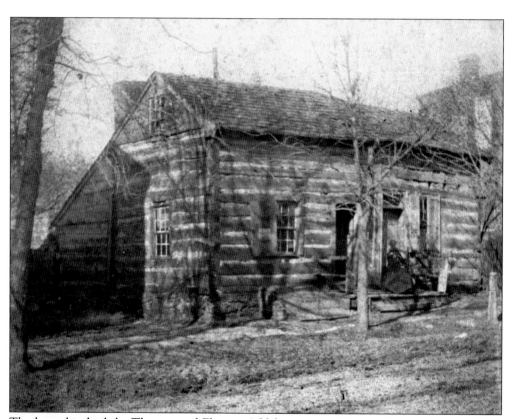

The log cabin built by Thomas and Eleanor Addelsperger in 1777 stood at the corner of East Main and South Court Streets. This stereograph shows the house as it appeared c. 1870, by which time it was home to Thomas's daughters Betsy and Margaret and Margaret's daughter Mary Ann. Both Betsy, who died in 1879 at age 85, and Margaret, who died in 1886, lived their entire lives in the small house.

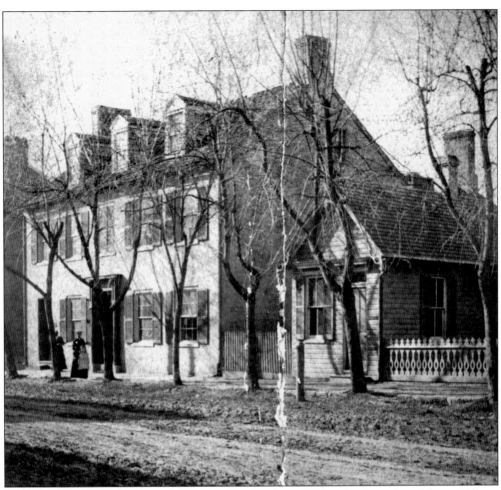

Jacob Sherman built a large brick home for his family in 1807 on land purchased from William Winchester Jr., the son of Westminster's founder. The house, at 206 East Main Street, was directly across the street from the tavern that provided Sherman's livelihood. Sherman's home combined the traditional Carroll County farmhouse with the ethnic traditions of Sherman's Pennsylvania German heritage, and architectural innovations such as counterbalanced windows and built-in cupboards. Local banker John Fisher moved into the house after Sherman's widow, Elizabeth, died in 1842. By 1864, Catherine Shellman and her four children—Fanny, Harry, Mary, and James—lived in the house. Mary Shellman recalled that Confederate general Bradley T. Johnson briefly occupied the house for his headquarters from 6:00 p.m. to midnight on July 9, 1864, during his raid, which he hoped would reach the prison camp at Point Lookout. Mary Shellman lived in the house until shortly before her death in 1938. In 1939, a group of local citizens formed the Historical Society of Carroll County to preserve the Shellman house and Carroll County history.

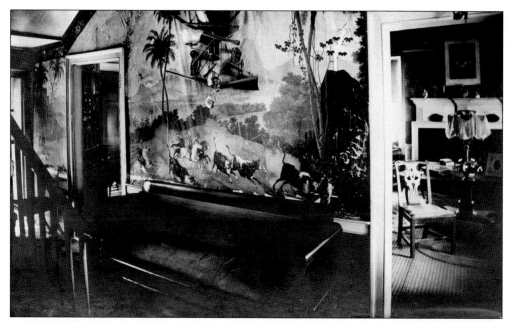

In the 1840s, John Fisher, the second owner of the Shellman house, installed decorative wallpaper in the central hall of the house. The paper, seen here in a c. 1907 image, was made in France by Zuber and titled "View of Brazil." The paper was hand-printed using 1,693 wood blocks in 247 colors. Mary Shellman removed the paper in 1931, stored it for safekeeping, and eventually sold it a Baltimore antiques dealer.

In the yard behind the Shellman House stood this simple log structure, originally used as a loom house. This photograph from the late 1800s shows Elizabeth Tyson and Henry Johnson. The 1870 census listed Elizabeth as a servant in the Shellman household. Elizabeth married Henry Johnson in 1881. The building was demolished between 1904 and 1908.

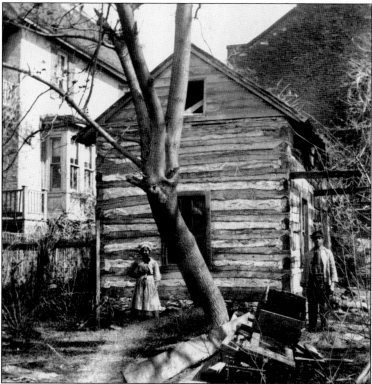

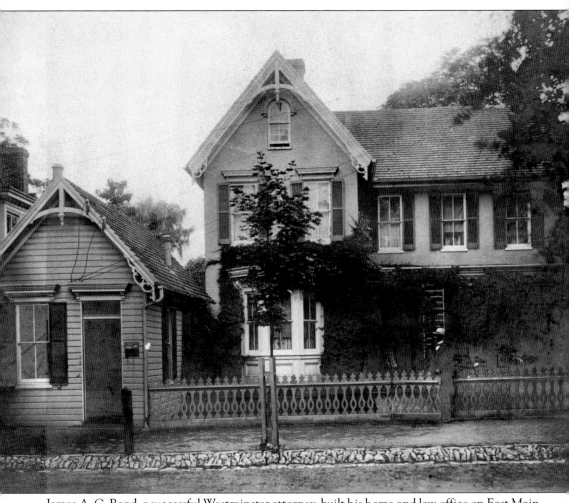

James A. C. Bond, a successful Westminster attorney, built his home and law office on East Main Street at the foot of Court Street. Bond served as an attorney for the B&O Railroad, a position he held for over 60 years, and in 1899, he was appointed an associate justice of the 5th District. Bond married Selina Fiddis in 1872 and a few years later began to build their home. The small frame law office was completed first, and the *Democratic Advocate* noted in June 1876 that "the masons have begun the brick work of the residence of Mr. Jas. A. C. Bond." The result was a modest L-shaped house. However, the house grew as the Bond family renovated every few years. With the last addition in 1914 of the red brick rear block, which housed what the Bond family referred to as the "law library," the house had almost doubled in size. Alice Bond inherited the house after her father's death in 1930, but she never lived there and appears to have leased the property.

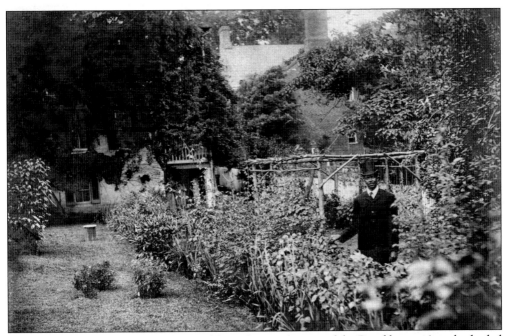

There were extensive flower and vegetable gardens at the rear of the Bond house. A path, shaded by a vine-covered arbor, ran from the back door of the house to the carriage house at the rear of the property. The gentleman in this early-1900s image is Norris Jones, who worked for Judge Bond for many years as chauffeur and gardener.

John Wampler constructed a large brick house (seen in this c. 1890 image) on the corner of East Main and Church Streets in the early 1830s. In 1837, the first Orphan's Court sessions were held here while the new courthouse was under construction. William Wampler inherited the property from his father but was forced to sell it in 1895 to settle outstanding debts. The Methodist church purchased the building, enlarged it, and used it as the Home for the Aged until 1950.

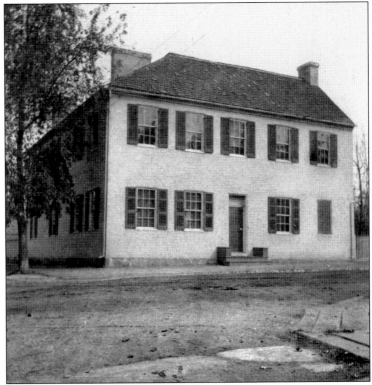

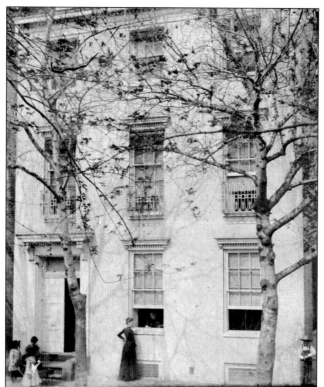

Dr. James Howell Billingslea settled in Westminster after graduating from medical school in 1864. He established his home and office at 189 East Main Street. The house appears to have been built in the 1860s, and an addition to the right, which served as Billingslea's office, had been added by 1877. Billingslea married Charlotte Spalding in 1884, and they had five children: Charlotte, James, Robert, Charles, and Leeds. The c. 1900 photograph above shows the house and what are presumably Charlotte Billingslea and several of the children. Below is an image of the Billingslea parlor as it appeared c. 1890. Charles Billingslea also became a doctor and opened his practice in his father's former office in 1920, three years after his father's death.

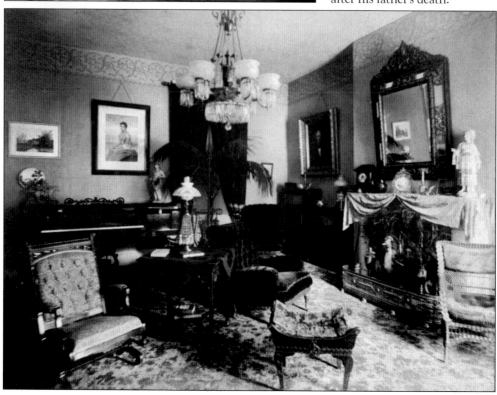

The house at 188 East Main Street was built for the Baumgardner family in the mid-1800s. The cast iron stairway and balcony led to the entrance to the main level of the house, a piano nobile style that is uncommon in Westminster. The lower level was intended as a law office, which proved uncomfortably damp. An addition to the house was constructed shortly after the Civil War.

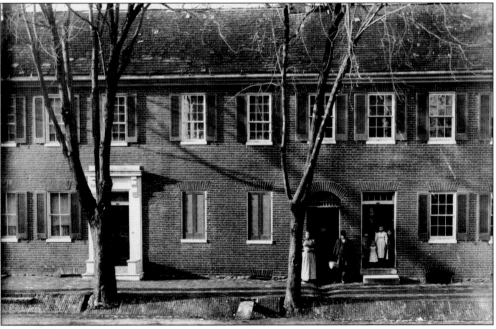

Philip Jones, an early Westminster merchant, built the brick house at 132–134 East Main Street around 1817. The building served as a residence and housed the family's store. Jones sold the house when he moved his family to Bangor, Maine, in 1835. Later, the *American Sentinel* newspaper occupied the house for a time. This image was taken *c.* 1890.

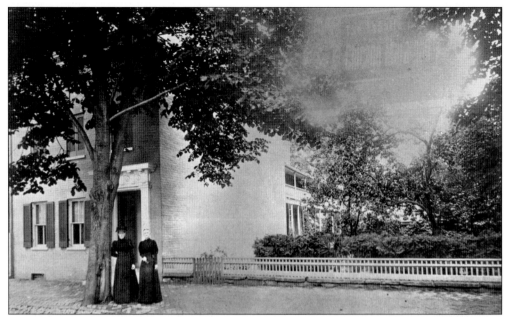

Widow Anna E. Fisher married William P. Maulsby on March 20, 1872. By that time, Maulsby had been Carroll County's first state senator; colonel of the First Regiment, Potomac Home Brigade; chief judge of the Sixth Judicial Circuit; and a member of the Court of Appeals. Shortly after their marriage, they built an impressive new home at 133 East Main Street. The Maulsbys hosted Pres. Ulysses S. Grant during his visit to Westminster on October 2, 1873.

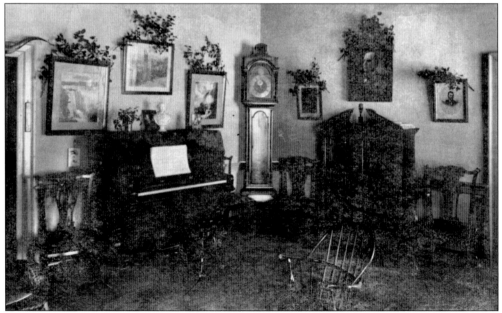

John Hannah worked as a clerk at William F. Derr's department store before taking a position at Babylon & Lippy. He lived at 102 East Main Street. This image shows the parlor of Hannah's home; the greenery decorating the pictures suggests that this image was taken around Christmas. The large picture is of Pres. William McKinley, indicating that the image was taken c. 1900 and that Hannah was probably a Republican.

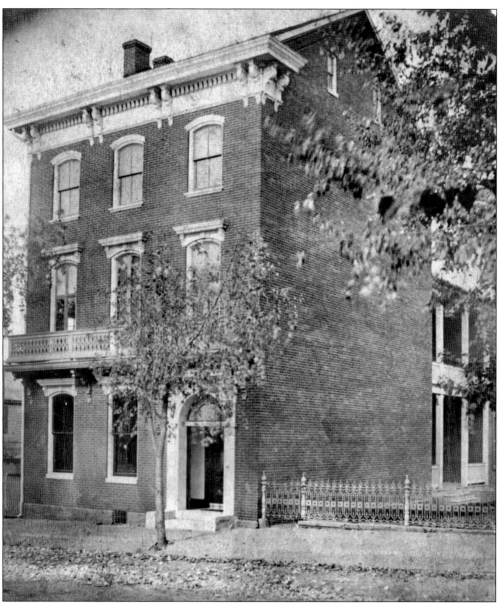

The house at 101 East Main Street was home to Charles Valentine Wantz, his wife, Caroline, and their children, James, Nellie, and Charles. Wantz was born in Frizellburg and, in 1869, moved to Westminster where he opened a cigar store. As his business prospered, he built a magnificent commercial building in downtown. In 1877, Wantz married Caroline Virginia Pearre. The lot at 101 East Main sold for $700 in 1873, but when Caroline Wantz purchased the property in 1880, she paid $7,100. This indicates that the house had already been built, though the exact date of construction is unknown. It is not known why Charles's name does not appear in the records of the purchase. The elegant, three-story, L-shaped house had a second-floor balcony overlooking Main Street, a two-story rear porch, and extensive gardens enclosed by a decorative iron fence. Caroline Wantz, listed as "widow of Charles," sold the house in 1923.

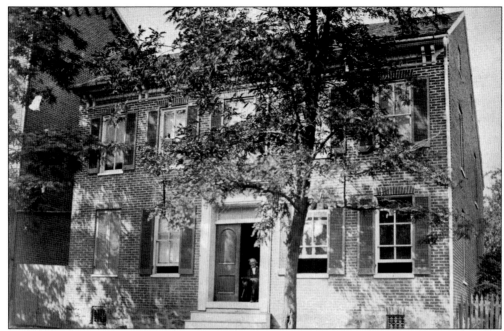

Thomas Goodwin, who ran a grocery store near the intersection of Main and Court Streets, purchased property at 98 East Main Street for $1,600 in March 1865. The high price suggests that the house seen in this image had been built by that time. Goodwin lived in the house with his wife, Ellen, and their two sons, Charles and Price. Charles inherited the house and owned it until 1936.

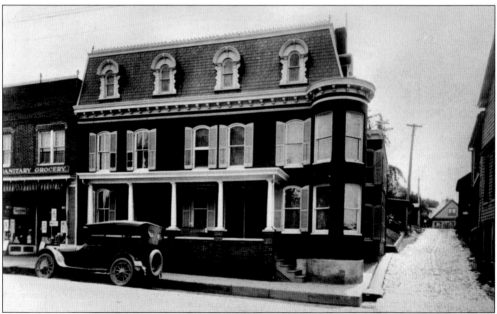

Paul Kaes bought the lot at 98 East Main Street for $200 in June 1868. When he sold the property to Ellen, Josephine, and Henrietta Case in 1877, it was valued at $1,900, so it seems that Kaes built the house. The Second Empire–style house is distinguished by its mansard roof and elegant dormers with elaborate hood moldings. The round corner room was a later addition to the parlor.

The earliest part of the massive house at 54–56 East Main Street was built *c.* 1875. The *American Sentinel* reported on July 16, 1892, that Oscar D. Gilbert had purchased the property and was "having the house enlarged and remodeled and making other improvements that will render it a very convenient and desirable residence." The result (above) was a distinctive chateau-like structure highlighted by an assortment of gables, turrets, and chimneys. On May 23, 1899, the Ladies' Aid Society of St. Paul's Reformed Church arranged for entertainment at the Gilbert house (below). The performers seen here are, in no particular order, Carrie Gehr, Carrie Shriver, Sarah Weeks, Edna Erb, Florence Mitten, Ralph Royer, Frank Thomas, Walter Graham, Edgar Sixsmith, and Will Mather.

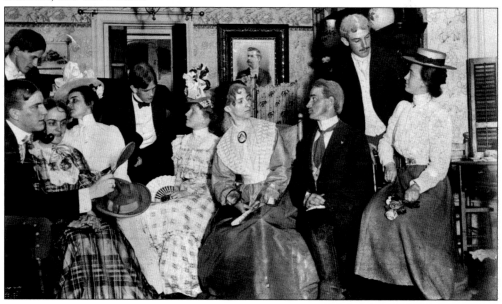

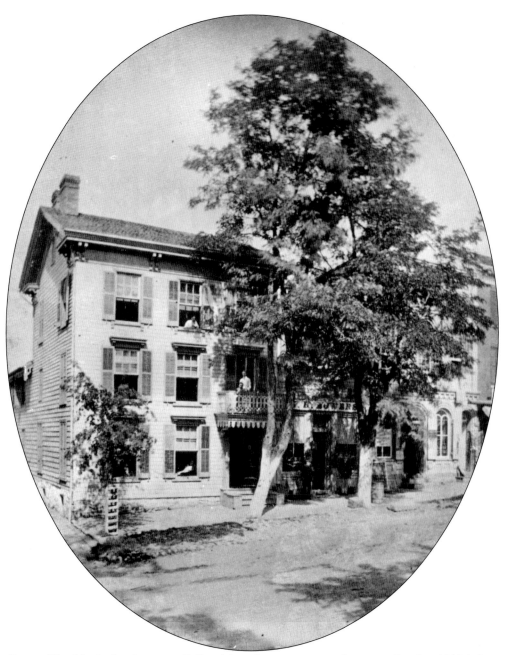

George Wivel built this home at 43 East Main Street sometime between October 1840 (when he acquired the land) and April 1845 (when he sold the property for five times what he paid for it). While its basic style is a vernacular clapboard farmhouse, the house included interesting architectural details such as the recessed front door and the French doors that led to a small second floor balcony, which can be seen in this photograph. The building changed hands several times and, by the mid-1900s, had been drastically altered for commercial use. Large display windows were installed across the front, the balcony was removed, and the entire structure was sheathed in asbestos shingles. The building was demolished in the late 1970s for the creation of the Locust Lane mall.

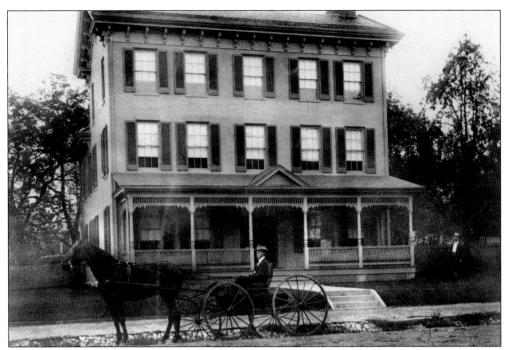

The Babylon house stood at 25 West Main Street until its demolition in the early 1960s. In this *c.* 1890 image, F. Thomas Babylon stands in the yard near the porch, while D. Snyder Babylon sits in the carriage.

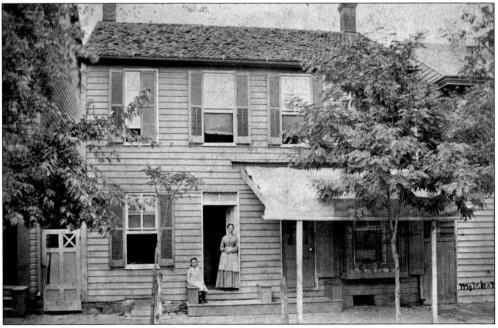

J. Thomas Erb purchased the house seen in this *c.* 1880 image from Dr. Lyman Swormstedt in 1880. The house stood on the north side of West Main Street, across from the Montour House hotel. The house was among the structures destroyed by a fire that roared through Westminster on April 9, 1883.

Joseph Orendorff built the house at 79 West Main Street, probably around 1850. By 1862, John Brooke Boyle and his family occupied the house. On September 11 of that year, Col. Thomas Lafayette Rosser and his 5th Virginia Cavalry arrived in Westminster from Gen. Robert E. Lee's Army of Northern Virginia, which was marching toward Frederick. Colonel Rosser made this house his headquarters. The cavalry departed the next day, but the house is still known as Rosser's Choice.

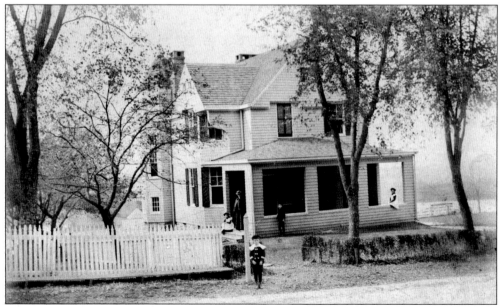

John L. Reifsnider Sr. built Westover as a present for his son John Jr. on the occasion of his marriage to Lethe Lisle in 1897. John Jr.'s house faced West Main Street, but the grounds were contiguous with his father's home, Terrace Hill. Together the two properties created a family compound of almost 5 acres. This photograph of Westover c. 1915 shows Lethe Reifsnider and her children.

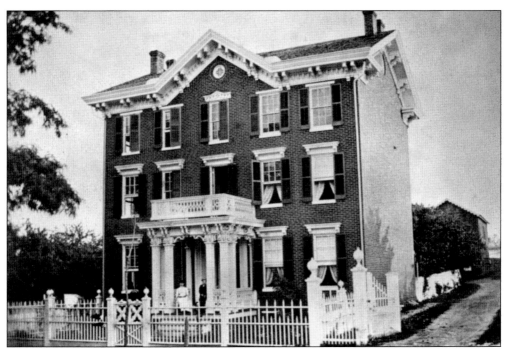

The house at 179 West Main Street (above) was built by William Rinehart in 1868. Rinehart owned a farm near Westminster and sold bricks made from clay on his land. According to family legend, in 1868, Fayette Buell ordered a large quantity of brick to be used for construction of Western Maryland College. When Buell cancelled the order, Rinehart decided to use the bricks himself and construct a house in town. The result was an impressive three-story home with walls 14 inches thick. Shortly after the house was completed, Rinehart posed with his family—including his wife, Caroline, daughters Margaret and Mary, and son William—in the yard at their new home in the image below. Despite his elegant townhouse, U.S. census records continued to list Rinehart as a farmer.

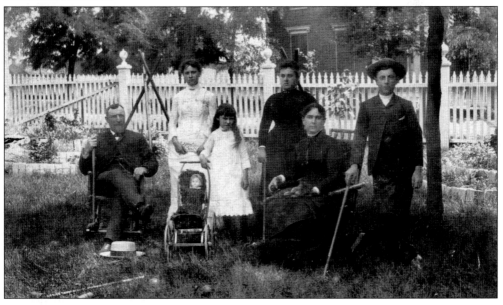

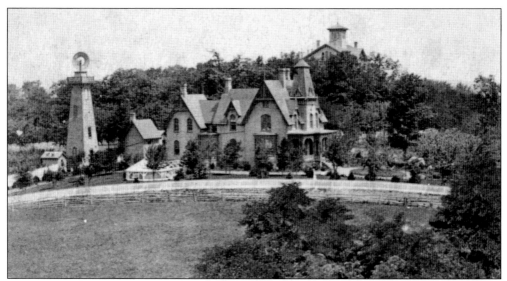

In 1865, John L. Reifsnider Sr. purchased 4.75 acres on College Hill. In 1873, construction began on a magnificent brick chateau to be called Terrace Hill (above, an 1870s stereograph view). Reifsnider surrounded his villa with stables, greenhouses, a five-story brick windmill, and a series of terraces that led down the hill toward West Main Street (hence the house's name). The house is now on the campus of McDaniel College. In the image below, taken in the early 1890s, the Reifsnider family posed in the grounds behind Terrace Hill. John Reifsnider is at left (holding the horse); his wife, Mary Anna, stands next to the pony cart in which her son Eltinge is seated; and Upton Morgan, who worked for the family, holds two of the family horses. One of the girls at the right is Louise Reifsnider; the others are unidentified.

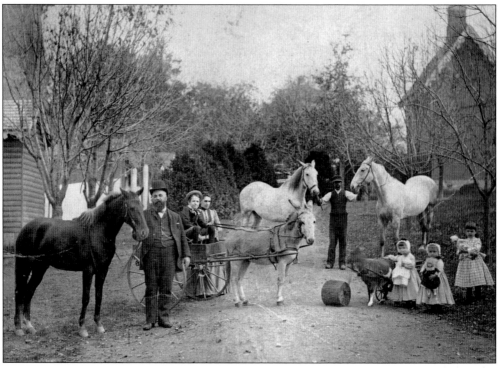

This house, on the campus of the Westminster Theological Seminary, was built in 1897 for Hugh Latimer Elderdice, the school's new president. Elderdice graduated from Western Maryland College and Yale Divinity School before being ordained in 1885. He and his wife, Annabel, lived in this house until 1924, when it was torn down and replaced by a larger brick house. Elderdice served as president for 35 years, resigning in 1932.

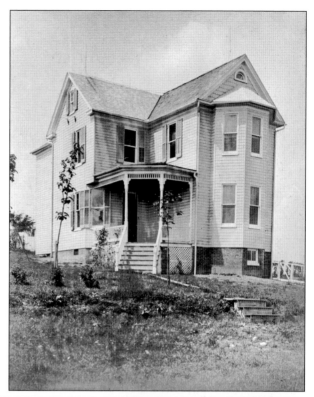

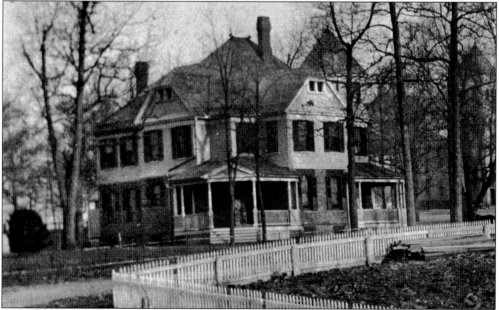

In 1887, the Baker family of Buckeystown pledged $4,000 to Western Maryland College for the construction of a residence for the school's president. The college retained architect Jackson C. Gott, who had previously designed the college chapel, to design the new house. Pres. T. H. Lewis was the first occupant of the house, which was completed in December 1899. The building remains the official residence of the school's president.

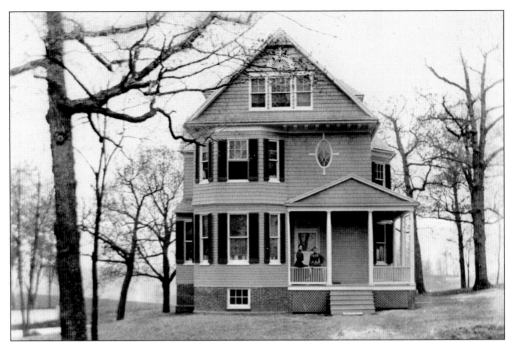

In the late 1890s, Western Maryland College built several homes on campus for professors, including this one for William Roberts McDaniel. The school invested $2,500 for the construction, while McDaniel contributed an additional $500 for the heating and plumbing, and paid $150 annually for rent. McDaniel had graduated from the college in 1880 and returned as a professor in 1885. McDaniel and his wife, Ada, (seen below in their parlor) lived in the house for more than 40 years. The building then housed the home economics department and a child development nursery school. McDaniel House is still in use today as the American Sign Language immersion house, a part of the college's deaf education program.

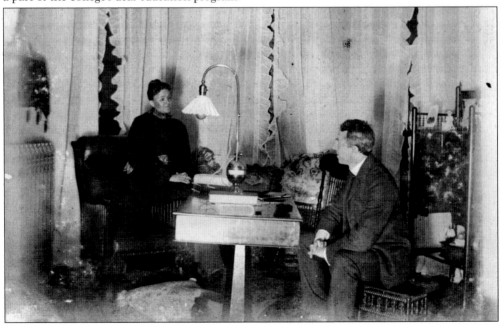

Five

HOUSES OF LEARNING

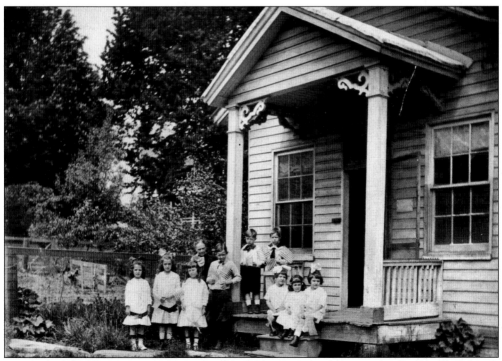

The first school in Westminster opened in the early 19th century, in the brick building on Church Street near the entrance to Westminster Cemetery. Other private schools operated in homes and in the Odd Fellows Hall. Seen here is the school run by Jennie Pole on East Main Street. One of her students later recalled that she "had a wonderful rapport with children and gave us a basic appreciation of the joy of learning."

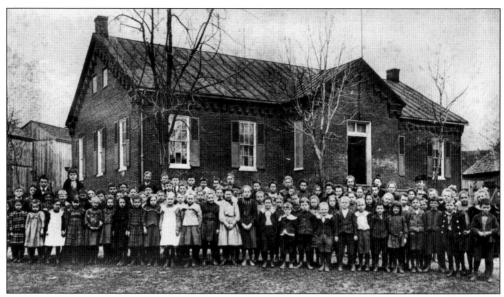

In 1864, Maryland enacted a law calling for a system of public schools in the state. In Westminster, classes were held in rented facilities until the completion of West End School in the early 1870s. The school sat in the center of the triangle formed by Union Street, Main Street, and Pennsylvania Avenue. At that time, teachers received $50 per year, with a bonus for each student above 15 per class. The West End students posed in front of the school for this 1907 photograph (above). A second story was added to the building in 1910. The fourth grade posed in front of the enlarged school on September 28, 1925, for the image below. The building was enlarged twice more in the 1950s. The school closed in 1976.

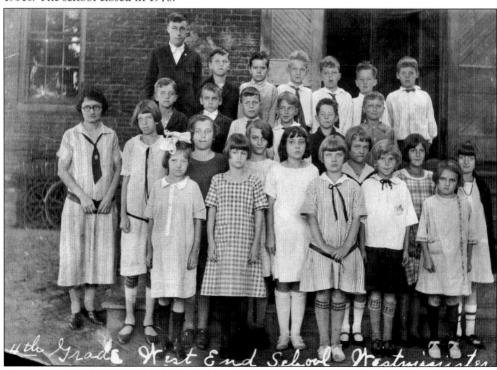

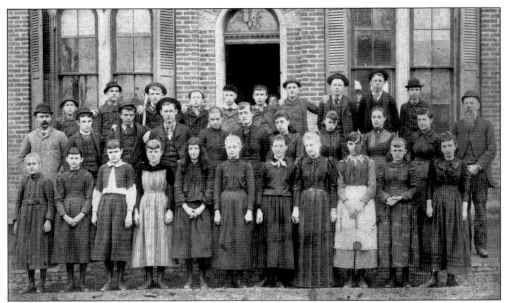

In 1885, Central Hall School was constructed at the intersection of Center and East Green Streets. There were five classrooms, one each for the first four grades and a large double room for the fifth and sixth grades. Above are the Central Hall students in 1890. Among those pictured, in no particular order, are (first row) Blanche Buckingham, Ora Whitmore, Hattie Huber, Blanche Trumbo, Rachel Buckingham, Nan Mather Rinker, Carrie Mourer (first grade teacher), Elle Mobley, and Maggie Himler; (second row) George Morelock (fourth grade teacher), William Mather, Harry Miller, Ed Helwig, Bessie Stoner, Mollie Bixler, ? Fowler, Miriam MacSweney, Bertie Buckingham, Ida F. Lockard (third grade teacher), and Simon P. Weaver (principal, 5th and 6th grade); (third row) Harry Main, John Miller, Emory Buckingham, Jesse Stephan, Arthur Stonesifer, Clarence Main, Edgar Miller, Clifton Cook, and George Mobley. Below are the Central Hall third grade students and their teacher, Mrs. McGuire, c. 1895.

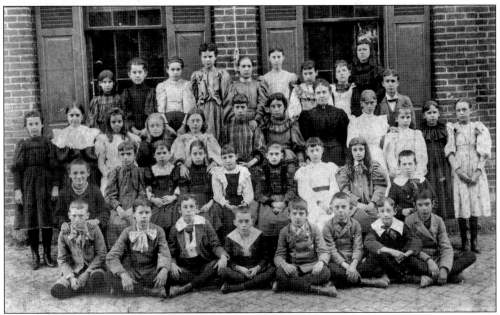

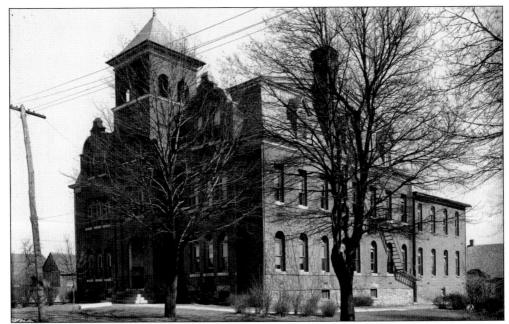

In 1899, a new school was built on the Center Street site. The new structure was a large, three-story building with a distinctive cupola. The school housed the high school and elementary grades until 1918, when the younger students were moved. After the high school students moved to a new school on Longwell Avenue in 1936, the elementary students returned to the Center Street building. The school closed in 1976.

This photograph shows the Westminster High School class of 1912. From left to right are (first row) Charles Arnold, Paul Englar, James Marsh, Clarence Aldridge, John Magee, and LaMotte Smith; (second row) Grace Gunther, Rubie Yeiser, Velma Fleming, Mabel Albert, Irene Lippy, Mary Weagly, and Jessie Knadler.

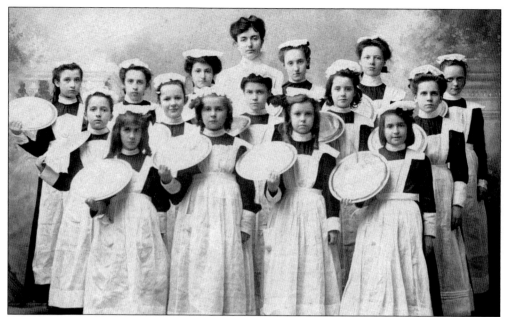

Students at the Center Street school studied a variety of subjects. The girls in this *c.* 1910 image are practicing their waitressing skills. Among those pictured, in no particular order, are (first row) Eloise Miller, ? Gehr, Marie Shaw, unidentified, and Henrietta Roop; (second row) Ella Shipley, unidentified, Isabel Roop, Blanche Williamson, and unidentified; (third row) unidentified, Marguerite Stem, Anna Yingling, Lillian Franklin, Mabel Armacost, and unidentified.

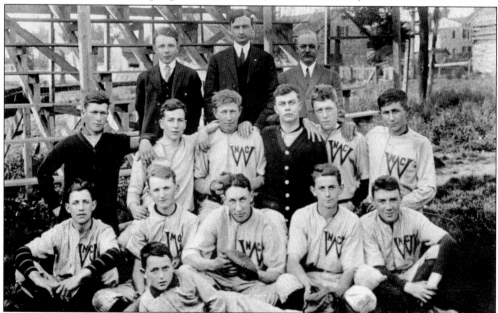

Team manager T. Cash, principal C. H. Kolb, and county superintendent G. F. Morelock (in the third row) posed with the 1914 Westminster High School baseball team. In the front is mascot W. Arnold. Also pictured were (first row) E. Bell, RF; P. Shaffer, 3B; S. Beacham, 1B; C. Diffendal, P and LF; and captain Arnold, C; (second row) P. Little, substitute; H. Grumbine, SS; C. Masonhimer, 2B; L. Billingslea, P and LF; H. Whitmore, LF; and W. Masonhimer, CF.

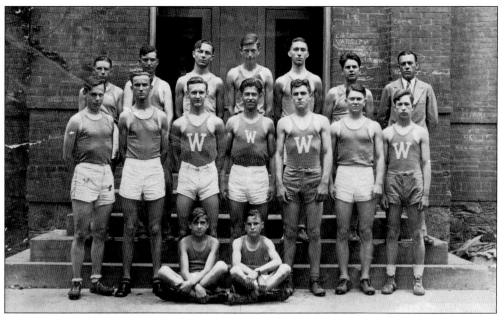

The Westminster High School track team posed in front of the school in 1931. Pictured were (first row) Henry Blizzard and Hubert Caple; (second row) Carter Stone, Woodrow Peeling, Everett Jones, Thomas Boller, King Gehr, Donald Ebaugh, and Arthur Eckenrode; (third row) Edward Setterburg, unidentified, Louis Brown, Sterling Fowble, Burns Houck, Bruce Brandenberg, and Lyman Earhart.

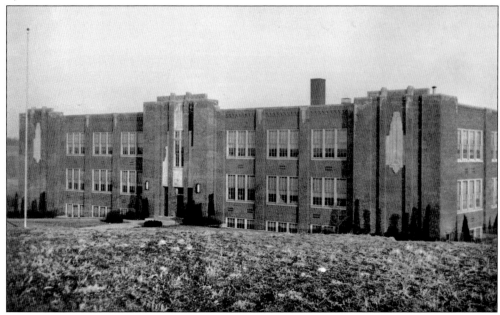

The new Westminster High School opened on Longwell Avenue in 1936. The art deco–style building, constructed of brick, steel, concrete, and Indiana limestone, was touted as absolutely fireproof. Facilities included 12 classrooms, domestic science and sewing rooms, metal and wood shops, music and typing rooms, and 1,700 fireproof lockers. After a larger high school opened on the Washington Road, the Longwell facility became East Middle School.

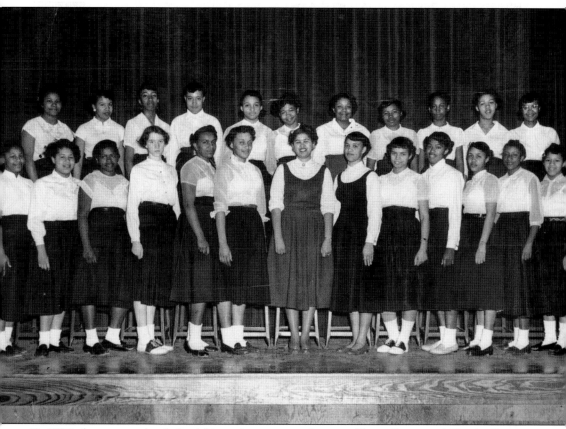

By 1892, there were schools for African American students on Union Street and Charles Street. A high school curriculum was added to the Union Street school in 1922. In 1930–1931, the high school students were moved to the corner of Charles and Church Streets. This became the only African American high school in Carroll County. The high school consisted of two portable buildings placed on the hillside to create a two-level facility. The year after it opened, the school was christened Robert Moton High School. In 1934, the school's PTA purchased a school bus that traveled the entire county picking up students. By 1937, one hundred students attended the school. During the 1930s, more portable buildings were added, and the activities expanded to include sports, dramatics, and chorus. This image shows the chorus, directed by Margaret Jackson, in the early 1950s. In 1948, the school moved to a new building on Center Street near the intersection with Charles Street. In 1955, Carroll County schools were integrated, and the high school students began attending schools near their homes. At that time, Robert Moton became an elementary school.

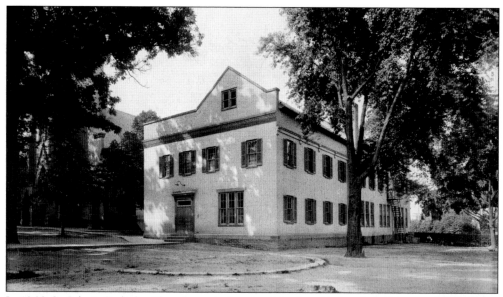

In 1866, St. John's Catholic Church opened a school in the old church building on Main Street with Charles Eckenrode and Miss Dulaney as the teachers. In 1872, the old church was demolished and the bricks used to construct a new two-room school. The school (above, in an early 1900s image) was enlarged in 1898, and members of the School Sisters of Notre Dame joined the faculty. A high school program was added to the curriculum in 1927. Below is an interior view of the school during an unidentified event in the late 1930s. Overcrowding led the parish to open a new high school on Monroe Street in 1958. The elementary students moved to Monroe Street in 1969, when the high school closed. The Main Street building was razed in 1977.

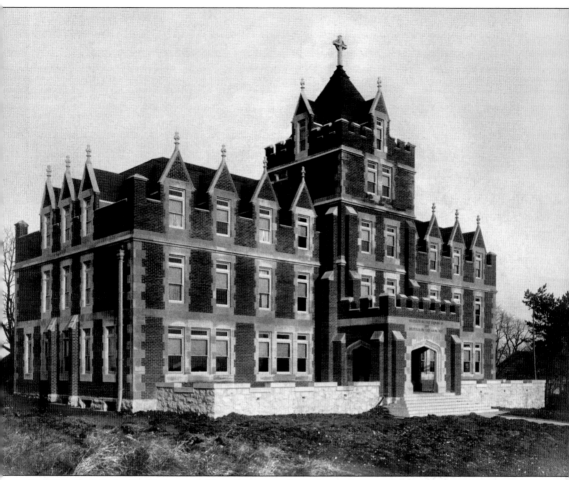

In 1881, the Methodist Protestant Church proposed creating a department of theology at Western Maryland College. The following year, the college's board of trustees approved the idea, appointing T. H. Lewis as principal of the department. Five acres of land adjacent to the college were purchased, and a new building was constructed for the additional students. Classes began in September 1882. Lewis soon realized that a more practical idea was the establishment of the seminary as a separate institution. The Westminster Theological Seminary of the Methodist Protestant Church was incorporated in 1884. Western Maryland College ceded the building and land to the new institution. The original seminary buildings were enlarged several times over the decades. Then in 1920, they were replaced by this magnificent Gothic structure designed by Paul Reese, which housed the seminary chapel, library, classrooms, offices, and dormitory rooms. In 1958, the seminary moved to Washington, D.C., and was renamed the Wesley Theological Seminary. The seminary building was renamed Elderdice Hall and became the administration building for Western Maryland College.

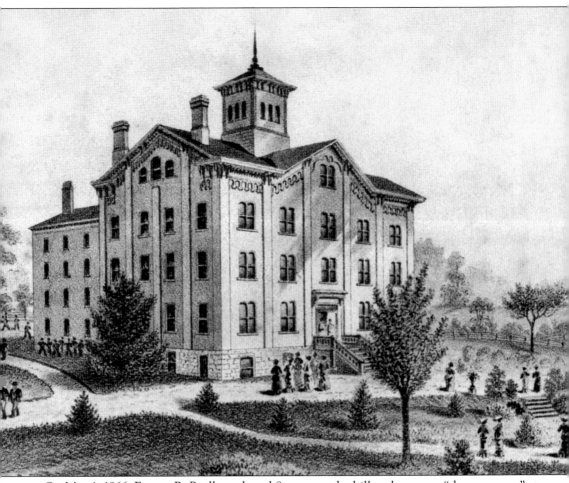

On May 1, 1866, Fayette R. Buell purchased 8 acres on the hilltop known as "the commons" at the western end of Westminster for the purpose of establishing a college. Buell received financial support from J. T. Ward, a Methodist minister who would become the college's first president, and John Smith, president of the Western Maryland Railroad. The first stone for the Main Building was laid on August 27, 1866, and the cornerstone was laid on September 6. The Western Maryland Railroad offered free rail passage to everyone who attended the cornerstone ceremony. This lithograph shows the completed Main Building in the early 1870s. The opening exercises for the first academic year at Western Maryland College were held on September 4, 1867, with college president J. T. Ward, five teachers, and 30 students (men and women) in attendance. The school was one of the first coeducational colleges in the country and the first south of the Mason-Dixon Line. Since its founding, the college has grown to over 1,600 students on a 160-acre campus that includes over 40 buildings. In 2002, the school changed its name to McDaniel College.

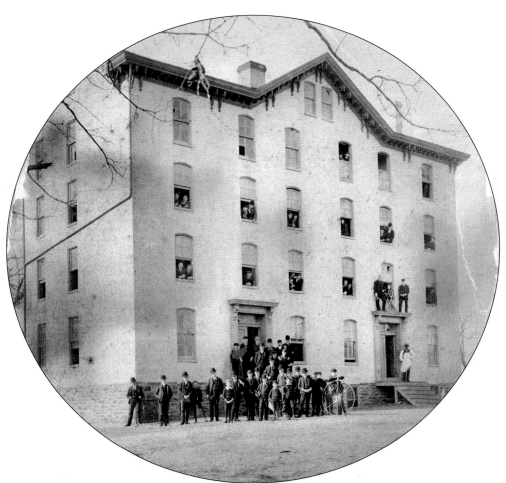

The first separate dormitory building at Western Maryland College was Ward Hall. In the college's early years, all students were housed in the Main Building or in rented rooms in town. Conditions were overcrowded, with six students often sharing rooms designed for two occupants. The cornerstone for Ward Hall, named for J. T. Ward, the school's first president, was laid on August 21, 1882, and the first residents moved in on February 20, 1883. Thirty-two male students occupied the new dormitory while the female students continued to live in the Main Building. Ward Hall was remodeled several times over the next few years and was finally demolished in 1895 to make way for a new, larger Ward Hall.

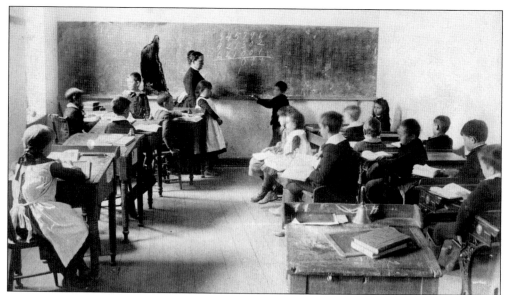

Western Maryland College ran a primary school, beginning in 1886, as part of its preparatory program. This photograph from 1886 shows the primary students, from left to right, Miriam Lewis, Nat Keen, Lewis K. Woodward, E. Oliver Grimes Jr., Harry Gorsuch, Jane Woodward, Denton Gehr, two unidentified, Paul Reese, George Sharer, unidentified, Clara Bankard, Grove Lawyer, unidentified, Clarence Billingslea, and James A. Bond. The primary school was phased out in 1898.

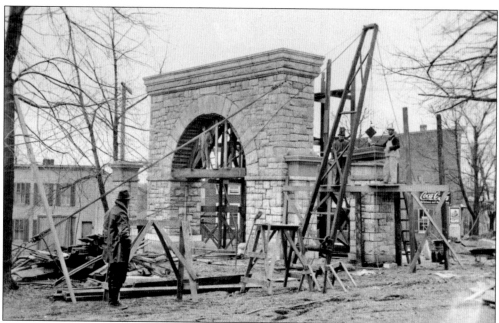

Western Maryland College constructed the Ward Memorial Arch in 1898 in honor of J. T. Ward. In 1936, the arch was dismantled and the stones numbered for reassembly at the corner of Main and Union Streets. However winter set in and by spring, many of the numbers had washed away. Luckily Harry Ditman had sketched the arch and numbers on his lunch bag. The arch was successfully reconstructed and still greets visitors to the campus.

Six

HOUSES OF WORSHIP

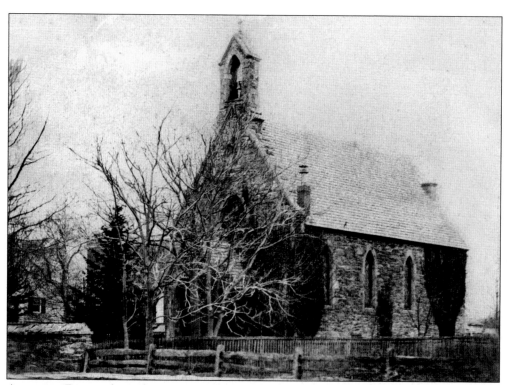

Ascension Episcopal parish was organized in 1844. The church, constructed of stone quarried near Westminster, was designed by Baltimore architect Robert Carey Long. The cornerstone was laid on August 27, 1844, and the church was consecrated on Ascension Day in 1846. The church was lit by candles until 1862, when kerosene lamps were introduced. This 1862 image shows the church before the stone wall was constructed in 1900.

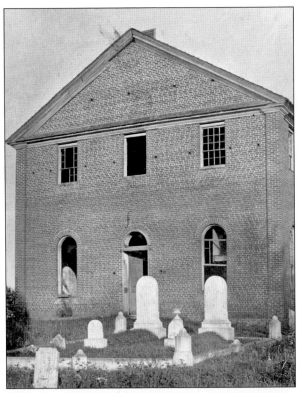

This brick Union Meeting House stood in the Westminster Cemetery and was used by several denominations. Built in 1811, it replaced a pre-Revolutionary War log structure. Beginning with its second session in September 1837, the Circuit Court of Carroll County met here until the completion of the courthouse. In 1863, the building served as a hospital for those wounded in the Corbit's Charge battle on Westminster's Main Street and in the battle at Gettysburg. Mary Shellman, a local girl who was 14 at the time, helped to nurse the wounded and many years later recalled that the pulpit (below) bore "many autographs and pathetic messages of the soldiers who spent that memorable week under its friendly roof." The cemetery board sold the structure in 1891. The image above shows the building as it was being demolished in 1892.

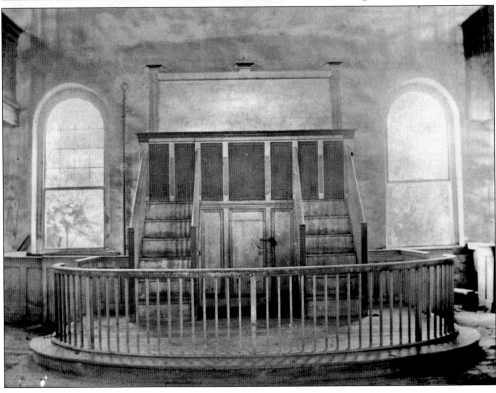

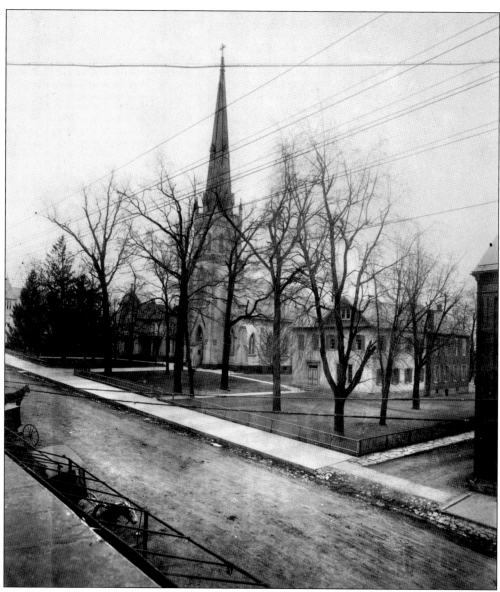

The cornerstone for St. John's Catholic Church was laid on April 29, 1865, and the Victorian Gothic building was dedicated on November 22, 1866. The church's steeple remained unfinished until 1871, when the parish raised $20,000 to complete the structure. Though it presented an impressive appearance, the steeple seemed to haunt the parish. By the late 1930s, the steeple had developed a disturbing lean towards Main Street and had to be repaired. Disaster struck in 1952, when a fierce storm toppled the steeple. An eyewitness account that appeared in the *Carroll County Times* reported, "The steeple was intact after breaking off until it leveled off horizontally and then dropped through the rectory causing further damage. The back upper wall of the rectory fell over in a delayed action after the original impact." The church was repaired, but the steeple was never replaced. In 1968, engineers condemned the church after discovering that the walls were separating from the roof structure. The parish opened a new church on Monroe Street in 1972, and the old church was razed in 1977 to make way for a new library.

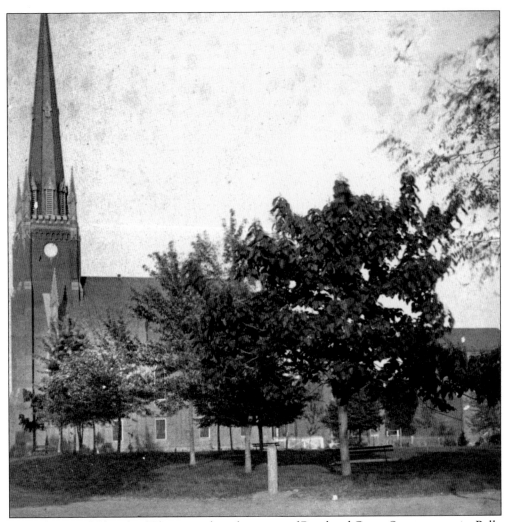

St. Paul's United Church of Christ stands at the corner of Bond and Green Streets, opposite Belle Grove Square. As early as 1820, members of the German Reformed Church held services in the old Union church. Work began on St. Paul's in 1868, though the congregation did not officially exist and would not be chartered until June 1870. This stereograph from the 1870s shows the church as it appeared shortly after completion. Extensive remodeling was done in 1923 and again in 1956. The later renovations included the addition of nine tons of steel to the support trusses and the placement of a rose window above the altar. In 1934, the German Reformed Church merged with the German Evangelical Synod to form the Evangelical and Reformed Church. In 1957, the Evangelical and Reformed Church merged with the Congregational Christian Churches to form the United Church of Christ.

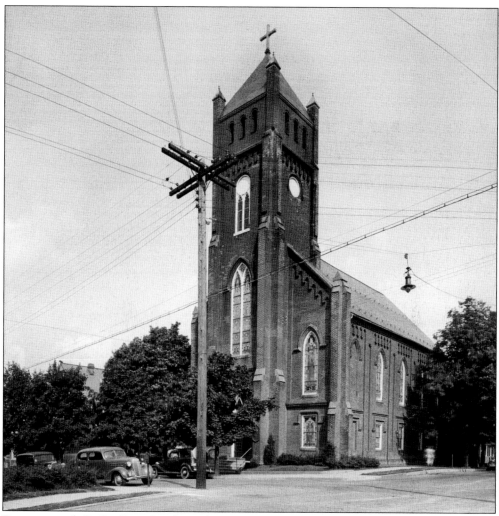

Disaster struck St. Paul's on Sunday, February 19, 1893, when a storm tore through the city and destroyed the church steeple. The *Democratic Advocate* reported, "The greatest damage from the storm, in this city, was probably sustained by St. Paul's Reformed Church, the towering steeple of which was blown down and now lies in the adjoining grounds. In its fall it struck the slate roof on the northeast side of the brick tower and crushed it over a considerable space, breaking, at the same time, some of the sustaining timbers. Some large stone ornaments were also knocked from the tower and front wall of the church, and the bell wheel was broken. A number of the memorial windows of the edifice were broken and the roof on the southwest side was somewhat damaged by timbers from the residence of Mr. Thomas H. Bankard, about a hundred yards west on Bond street. The church is probably damaged to the amount of $2,000." The church was repaired, but the steeple was never rebuilt.

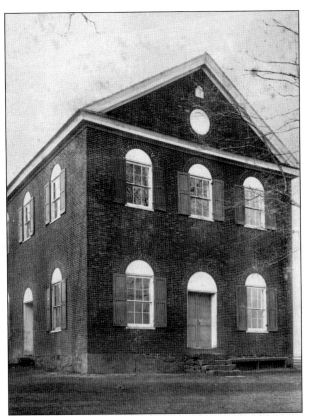

In 1763, the German Reformed and Lutheran congregations built a small log church on a piece of land acquired from Jacob Greider on the outskirts of Westminster. The church was originally referred to as Greiders, which evolved into Krider's. The two congregations used Krider's Church on alternate Sundays. In the early years, the services were conducted in German, which was gradually replaced by English. In 1807, a brick church (left) replaced the log structure. In 1836, the congregations were incorporated as Benjamin's Reformed and Lutheran Churches. In the late 19th century, the church suffered severe damage in a storm and had to be razed. At that time, the Reformed and Lutheran congregations decided to build separate churches. The new Krider's Reformed Church was completed in June 1890. A parish house was added to the church in 1937 (below).

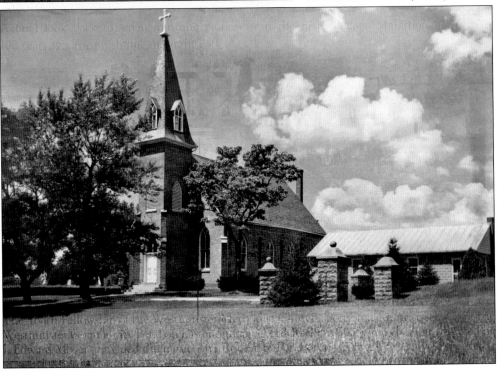

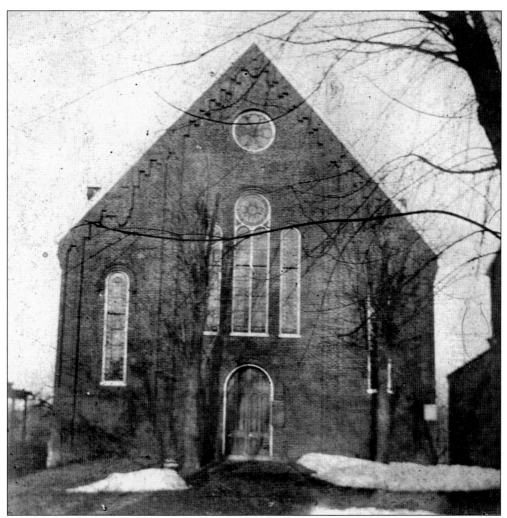

The first Methodist services in Westminster were held in the old Union church. In 1841, a new Methodist Episcopal church called Centenary Chapel was dedicated. The name of the church was later changed to Centenary Methodist Episcopal Church. In 1869, the parishioners raised money for the construction of a new church. Among the donors were the Cassell sisters, who gave money so that a bell tower would not be constructed. Apparently the bells at St. John's Catholic Church disturbed the neighbors, and the sisters did not want their church to cause a similar problem. The new church was dedicated on January 6, 1870. A social hall was added at the rear in 1913. Centenary Methodist Episcopal Church merged with Immanuel Methodist Protestant Church in 1941 to become the Westminster Methodist Church. The church formerly known as Centenary became the home for the new congregation.

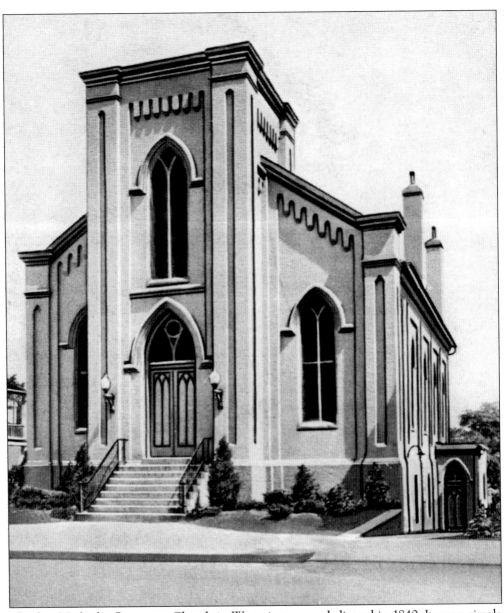

The first Methodist Protestant Church in Westminster was dedicated in 1840. It was a simple brick structure, lit by oil lamps and heated by wood stoves. The congregation grew quickly and soon outgrew the old church. Joshua Shorb, a local architect, designed an impressive new church, and construction began in 1868. Services were held in the basement—the first area of the church to be completed—while construction continued upstairs. The finished building, known as Immanuel Methodist Protestant Church, was dedicated on March 6, 1870. The new church was topped by a soaring steeple and bell tower. The steeple stood until 1924, when it was condemned as structurally unsafe and demolished. This image shows the church as it appeared soon after the removal of the steeple. Also in 1924, eight new windows were installed. Immanuel Methodist Protestant Church merged with Centenary Methodist Episcopal Church in 1941 to become the Westminster Methodist Church. At that time, the Immanuel church building was closed. W. H. Davis purchased the building in 1949 and renovated it for use as the Davis Library.

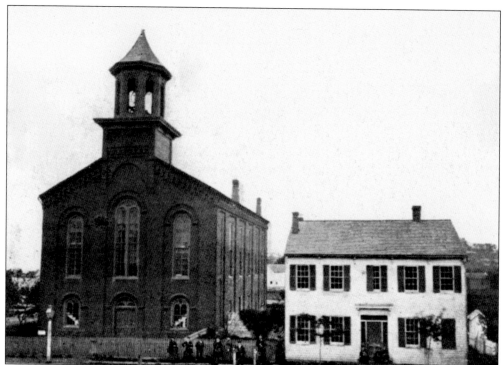

Grace Lutheran Church was organized on September 20, 1867, with 22 members. Ground was broken for the construction of a church on August 5, 1866, and the building was dedicated on February 23, 1868. The building (above) featured a distinctive cupola with a bell donated by Jacob Reese. The bell broke on a cold winter morning, and a new one was installed in August 1882. The fire that raced through Westminster on April 9, 1883, destroyed the church, parsonage, and the new bell. Construction of a replacement church began almost immediately and was completed in October 1884. The image at right shows the interior of the church decorated for a Harvest Home service in the early 1900s. In 1923, an organ and choir loft were erected to the right of the clock, drastically changing the interior.

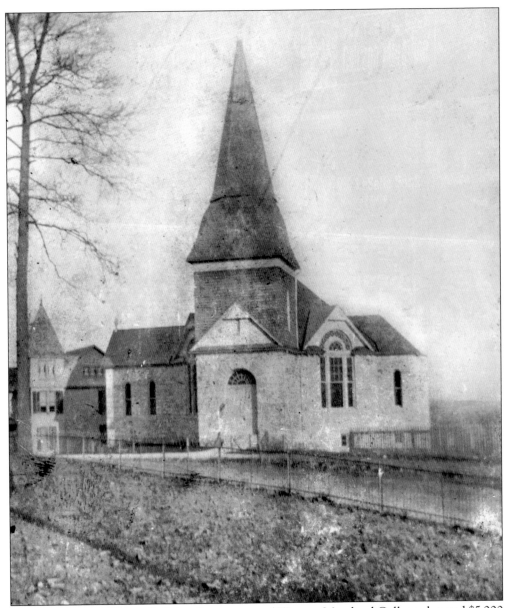

In October 1894, William G. Baker Sr., a trustee of Western Maryland College, donated $5,000 to the school for the construction of a chapel. The chapel was a thank you gift from the grateful father whose son had survived a serious illness the previous summer. His son William G. Baker Jr. had been valedictorian of the class of 1894. The college hired architect Jackson C. Gott, who had designed Westminster's Albion Hotel and would later design the president's house for the college, to design the chapel. Baker Chapel, with a seating capacity of 250, was constructed of white limestone and topped by an 87-foot tower. An anonymous donor provided the organ. This image shows the chapel as it appeared c. 1900. In 1952, the interior underwent major renovations, including installation of paneling over the original wainscoting, new carpeting, refinished pews, and installation of recessed floodlights. Also the chancel was redesigned with the altar, the pulpit, and lectern being enclosed by an altar rail. The chapel underwent renovations in the 1990s and was rededicated on May 7, 1995.

Seven

WESTMINSTER FIRE DEPARTMENT

In 1823, the Union Fire Company of Westminster erected the first firehouse in the city on Church Street. In 1834, the building was moved to East Main Street, opposite Court Street. In 1857, the city council disbanded the department and sold the engine and firehouse. After a number of serious fires, the department was reorganized in 1879. Seen here is one of the first helmets for the new fire company that belonged to Edwin Lawyer.

In February 1879, the newly reorganized fire department was incorporated as Westminster Fire and Hose Company, No. 1. The company used the building at 31 East Main Street to house its equipment, which included a hook and ladder truck (left), a chemical fire engine, and four chemical extinguishers. Upon completion of the town water system in 1885, the chemical engine was retired, and carts with reels of hose were added to the firefighting arsenal. Two hose houses, one at each end of town, were constructed in 1887.

The revival of the fire department in 1879 did not meet with universal approval. Concerns were expressed that the firefighters would not really be of much use in protecting the town. The department overcame these reservations by recruiting some of the town's leading businessmen. In 1895, the members of the fire department posed in front of the firehouse in their original uniforms that included white shirts and belts.

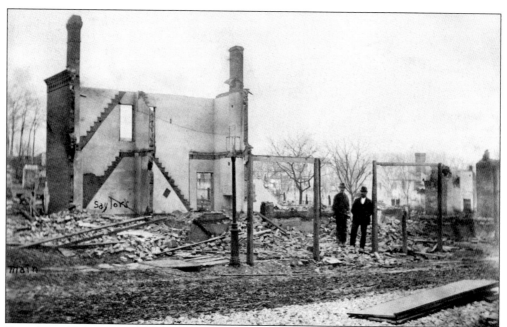

Tragedy struck Westminster on April 9, 1883, when Jacob Thompson's livery stable on West Main Street caught fire. The alarm sounded at about 11:30 p.m. By the time the firemen arrived, the stable was fully engulfed, and a strong wind was spreading the flames to neighboring structures. At the time, Westminster had no city water supply, and firemen fought the blaze with their chemical engine and water carried from nearby wells. By morning, the fire had destroyed 16 houses, Grace Lutheran Church on Carroll Street, two manufactories, and eight stables. Seventeen families and 13 businesses were left homeless. Total fire damage was estimated at $135,000. Two men who had been sleeping on the second floor of the stable where the fire began perished, as did a number of horses and cattle. Fortunately the city learned from the tragedy and installed water lines and fire hydrants.

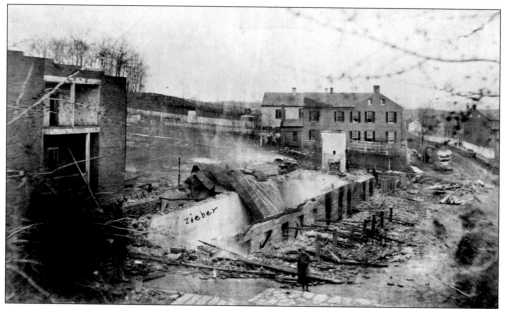

Built in 1896, the old firehouse on East Main Street dominates Westminster's skyline. Baltimore architect Jackson C. Gott, who had designed the Albion Hotel 10 years earlier, created the handsome three-story building. The Main Street facade is of buff-colored brick, with marble medallions commemorating the dates of the fire company's founding and the construction of the building. The building's tower rises to a height of 92 feet and is topped by a Seth Thomas clock, donated by Margaret Cassell Baile at a cost of over $1,000. The bell purchased in 1881 for the old building at 31 East Main Street was installed in the new tower. The weather vane atop the tower included a fireman's helmet at its center. The building housed the fire company's equipment on the first floor. The upper floors had meeting rooms, the city council chamber, the city clerk's office, a banquet hall, kitchen, and a lending library. This image was taken shortly after the building's completion. The fire company moved to a new facility on John Street in 1998.

The Westminster Fire Department hosted the annual convention of the Maryland State Firemen's Association on June 7–8, 1899 (above). The event included band concerts, hook and ladder contests, steam engine contests, and races. A parade (below, at the Forks) featuring 27 fire companies, 17 bands and drum corps, a troop of cavalry, and several hundred horsemen wound its way through Westminster for several hours. The *American Sentinel* reported that a carload of cots had "been ordered by the committee on public comfort for use during the convention. They will be distributed among private citizens who have consented to board visitors on the occasion." The Westminster department debuted new uniforms of blue coats, pants, and caps.

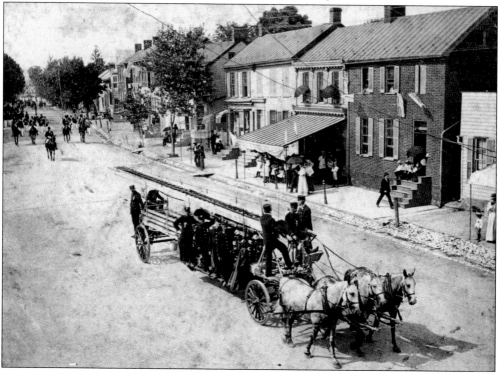

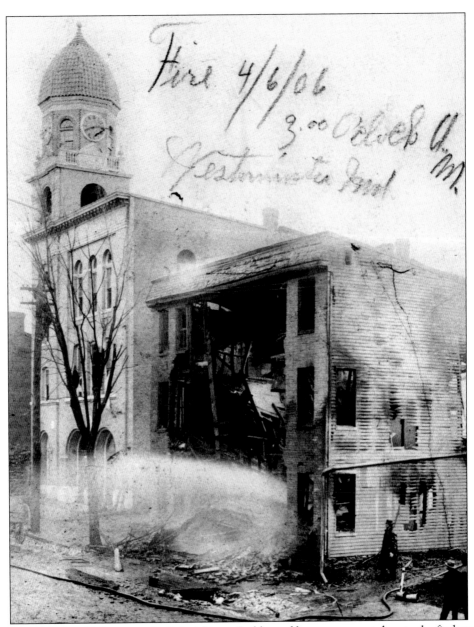

Henry H. Harbaugh's business, the Palace Livery Stable, and home were next door to the firehouse. A fire of unknown origin erupted there just before 3:00 a.m. on April 6, 1906. The fire began at the back of the building and swept through the frame structure so rapidly that Harbaugh, his wife, and their three sons barely escaped, fleeing the building barefoot and in their nightclothes. Harbaugh's losses amounted to over $18,000 and included 45 vehicles, harness, household goods and furniture, clothing, and 22 horses. The intense heat of the fire ignited the window frames of the firehouse and eventually spread to the interior of that building. The firehouse was saved, but it suffered extensive damage. Burning embers carried on the wind to the roofs of nearby houses, and residents used hoses and buckets to extinguish them and keep the fire from spreading. Smoke from the ruins still drifted down Main Street when this image was taken the next day. The firehouse was repaired, and Harbaugh rebuilt, but this time a fireproof building.

Firemen's conventions included competitions between the departments in events that were entertaining but that also demonstrated skills needed for firefighting. The prize money awarded in these competitions was also vital to the departments' finances. The Westminster Fire Department Hook and Ladder and Reel Team had an extremely successful season in 1912, winning over $700 in prizes. The team won the Hook and Ladder contest at the Cumberland Valley Volunteer Firemen's Convention in Waynesboro in early June. Two weeks later, the team captured three prizes at the Maryland Firemen's Association in Hagerstown: the Association Hose Race, the Open to World Hose Race, and the Open to World Hook and Ladder Race. From left to right in this photograph are J. G. Diffendal (captain), E. Gehr, J. Smith, F. Arnold, G. Bell, V. Daly, R. Crouse, W. Long, G. William, L. Billingslea, N. Boyle, S. Billingslea, and L. Zepp. Team members not pictured were E. Leary, E. Steffy, F. Weaver, L. Shaffer, M. Twigg, A. Birdsall, F. Dukes, and R. Elderdice.

In addition to hosting the Maryland State Firemen's Association convention in 1899 and 1914, the Westminster Fire Department traveled to locations around the state to attend the event in other years. The department's members posed for this photograph on June 11, 1908, in Frostburg.

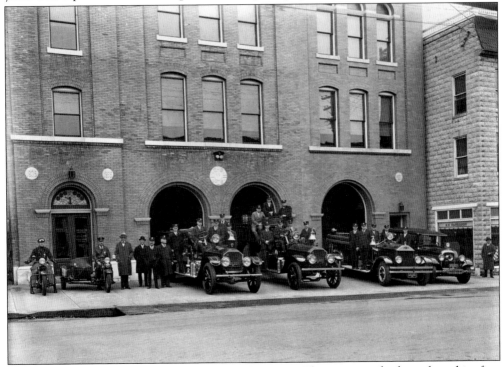

An addition to the firehouse was constructed in 1927. The company had purchased its first motorized engine—a 350-gallon pumper—in 1917. It was followed by a 750-gallon pumper in 1919 and a hook and ladder in 1924. Another engine would be added two years after the addition opened. This image of the firefighters and their equipment was taken in the early 1930s.

Eight

EVENTS AND ORGANIZATIONS

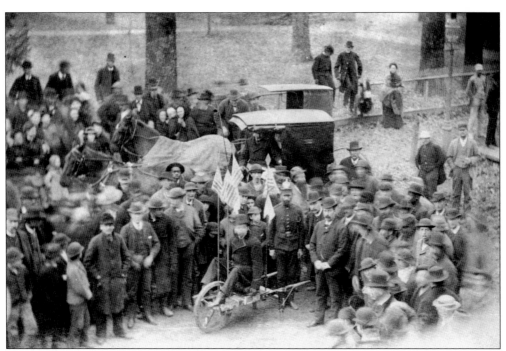

Each community develops it own unique traditions and events. In the 19th century, Westminster had an unusual political custom. Following an election, the loser pushed the winner in a wheelbarrow along the length of Main Street, accompanied by the town band. This image shows Charles V. Wantz preparing to take his victory ride. It is not known when or how this event started or why it ended.

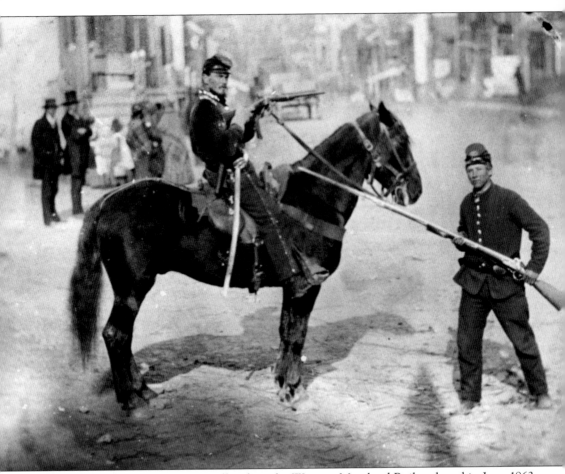

Westminster was an important railhead on the Western Maryland Railroad, and in June 1863, it was guarded by a small detail from the 150th New York Infantry, reinforced by 108 officers and men of the 1st Delaware Cavalry. This photograph of a member of the 1st Delaware was taken on Main Street. On the afternoon of June 29, Confederate general J. E. B. Stuart's cavalry approached from Sykesville. Capt. Charles Corbit led the Union troopers in a charge east on Main Street to the intersection of the Washington Road. A fierce skirmish ensued and spilled onto Main Street, where individual running battles continued until the Union troopers were finally overwhelmed by the large Confederate force. The 1st Delaware suffered 55 percent of its men killed, wounded, or captured. The victorious Confederates had two officers killed and a dozen men wounded. That night, Stuart's column rested along the Littlestown Pike near Union Mills. On July 1, Brig. Gen. Herman Haupt arrived in Westminster to take control of the Western Maryland Railroad, which became the primary military supply railroad for the Union forces engaged at Gettysburg. (Courtesy of Tom Gordon Jr.)

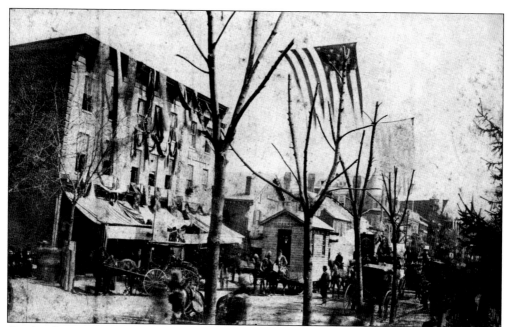

On April 11, 1887, Carroll County celebrated its 50th anniversary with what the *Democratic Advocate* called the "Greatest Celebration in Western Maryland." There were 20,000 visitors in Westminster for a gala parade that followed a 4-mile route through the city. This photograph shows the parade heading west on Main Street, passing the intersection with Liberty Street.

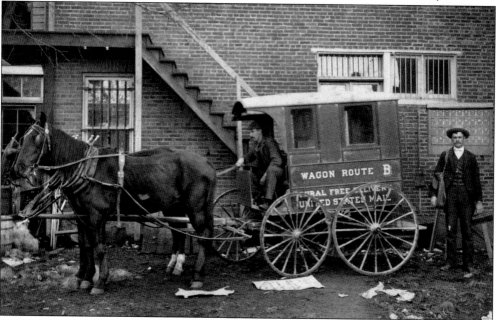

In 1899, the U.S. Postal Service selected Carroll County for the first countywide Rural Free Delivery service in the country, thanks to the efforts of Edwin W. Shriver. His plan relied on a postal wagon of his own design called the "Post Office on Wheels." Shriver made his first test run on April 3, 1899. In this image, clerk Atlee Wampler and driver Charles Swartzbaugh prepare to leave on their route.

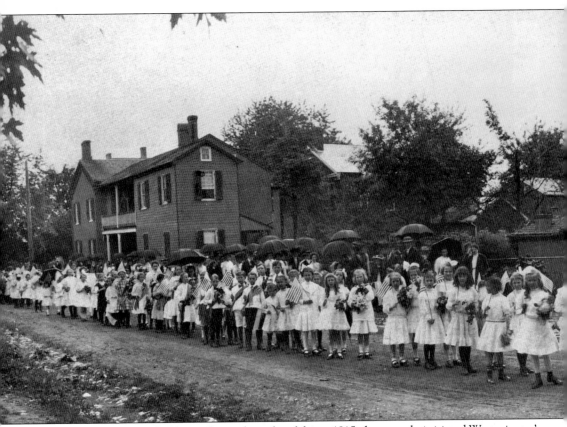

Mary Shellman, seen holding a flag at the right of this c. 1915 photograph, initiated Westminster's Memorial Day parade on May 30, 1868, when she organized local schoolchildren to place flowers on the graves of Westminster's Civil War dead from both sides. The parade began at the west end of town and proceeded east on Main Street to Westminster Cemetery's entrance on Church

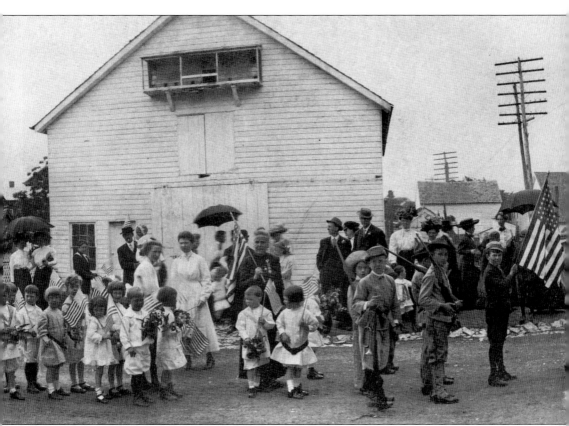

Street. Shellman ran the annual event until 1880, when Westminster's Burns Post No. 13, Grand Army of the Republic, took over the task. Westminster has continually observed Memorial Day longer than any other city in the country, and the event still includes children laying wreaths at the cemetery to honor the city's servicemen.

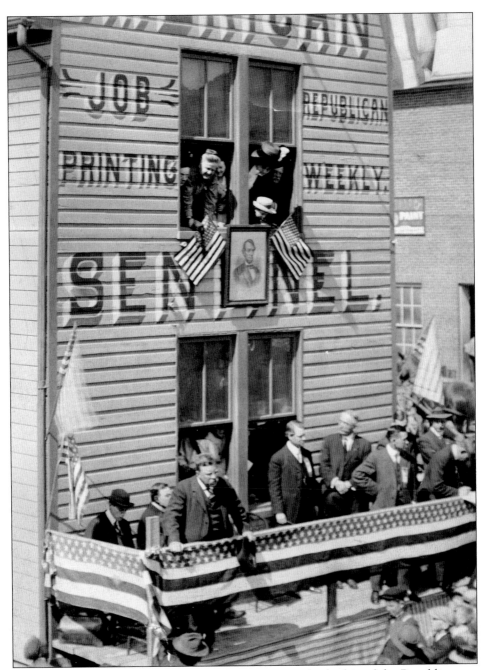

Pres. Theodore Roosevelt left office in 1908, turning over leadership of the Republican party to William Howard Taft. By 1912, Roosevelt was back, challenging Taft in the primaries for the Republican nomination. In May, he embarked on a campaign trip that brought him to Maryland. On May 4, Roosevelt arrived in Westminster for a speech in front of the *American Sentinel* newspaper office near the intersection of Liberty and East Main Streets. The paper reported that about 1,500 people paid "strictest attention to every word uttered by the speaker" before Roosevelt boarded his train and continued on his way to Baltimore. Roosevelt would lose the Republican nomination and form his own party, the Progressive (Bull Moose) party, for the general election.

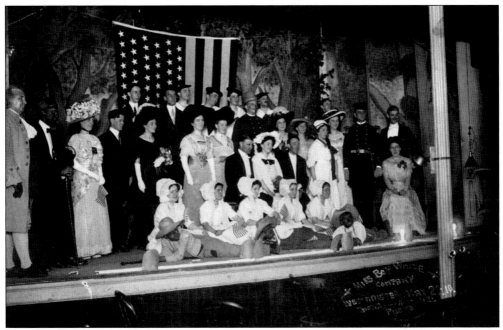

The opera *Miss Bob White* was performed in Westminster on Tuesday, May 10, and Thursday, May 12, 1910. The production by local singers and musicians, a benefit for the Westminster Orchestra, sold out both performances at the Odd Fellows' Hall. The *American Sentinel* raved that it was "the musical treat of this season and in fact within the history of this city."

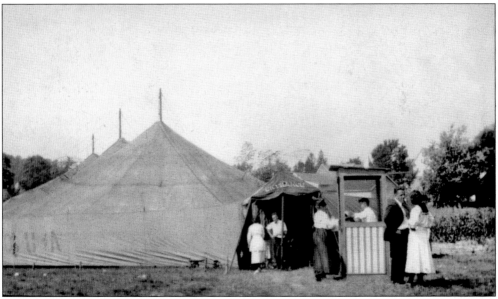

The Chautauqua movement of the early 20th century brought entertainment and culture to communities through speakers, teachers, and musicians. Small Chautauquas travelled a circuit, setting up in tents at each stop. The Chautauqua came to Westminster from August 31 through September 6, 1912. The highlight was the presentation by LaSalle Corbell Pickett, widow of Confederate general George Pickett. Over 300 season tickets were sold, admitting the buyer to all events for only $2.

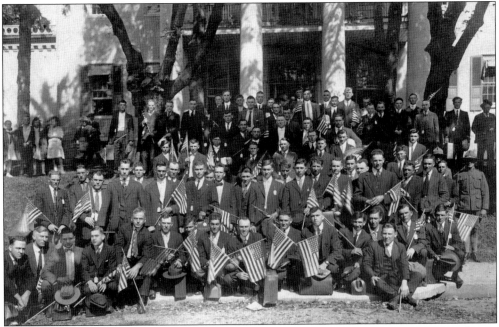

America entered World War I on April 6, 1917. By the fall, the Selective Service System began drafting men to fill the ranks. On November 5, 1917, the first group of local draftees posed in front of the Carroll County courthouse prior to departing for Camp Meade, Maryland. By the end of the conflict, nearly 1,250 local men and women had served in uniform.

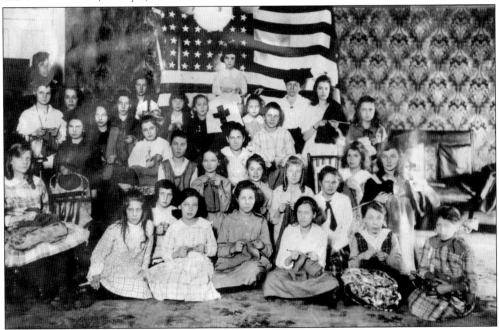

During World War I, the rapidly expanding American military outstripped the nation's industrial capability to produce all the items needed by service personnel. Red Cross chapters throughout the country, such as the junior Red Cross workers seen in this 1918 photograph, supported the war effort by making knitted items, bandages, and other materials needed by the troops.

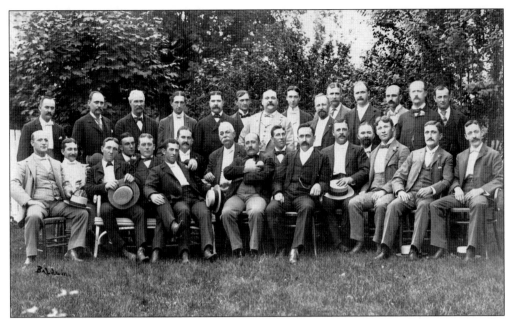

The "Baseball Invasion of Westminster" occurred on Sunday, June 21, 1896, when the Baltimore Orioles arrived at the home of Prof. James Diffenbaugh. Manager Ned Hanlon and his players, including Willie Keeler, Joe Kelley, and Wilbert Robinson, arrived on the morning train. Photographer J. W. Baldwin captured this image before the group left on the evening fast mail train. The Orioles captured their third consecutive National League pennant that year.

The Woman's Club of Westminster was established in 1912. The club presented *The Women Who Did* at the Opera House on Main Street on February 6, 1917. The cast included Mrs. G. W. Mather, Mrs. J. P. Wantz, Mrs. M. H. S. Unger, Mrs. Carroll Albaugh, Mrs. Jesse Myers, Helen Northrop, Mrs. James Beacham, T. H. Lewis, Mrs. H. L. Elderdice, Mrs. C. E. Forline, Martha Shaw, and Mrs. A. N. Wood.

In 1874, a group of local men established the Forest and Stream Club of Westminster for the purpose of protecting the fish and game of Carroll County. In reality, the group was a fishing club that each year went on a camping trip, often along the Monocacy River. This *c.* 1890 photograph shows the group in camp. In the front, from left to right, are Dr. Joseph Hering, Fred Miller, and Dr. George Bachman.

The Westminster Coon Hunting Club defeated four other clubs, winning a blue ribbon and cup at the Maryland Kennel Club Dog Show in Baltimore on April 16, 1915. The victorious hunters posed with their dogs and prizes at Naylor's Mill near Bruceville. From left to right are Edgar Wilhide (with Whitey), J. Carbery Boyle (with Drew), Thomas Case, and George Naylor (with Trailer).

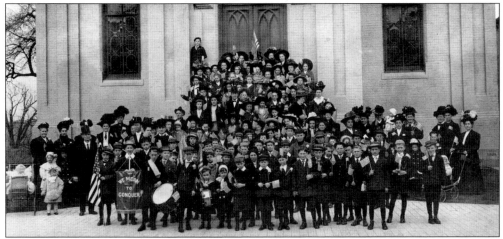

The temperance movement gained momentum in Maryland throughout the 19th century and led to the passage of the Local Option Law, which allowed each county to decide to become dry or remain wet. Temperance rallies, such as this one led by Mary Shellman (far left), proved an effective method of drawing attention to the cause. This photograph was taken in front of the Methodist Protestant Church on East Main Street.

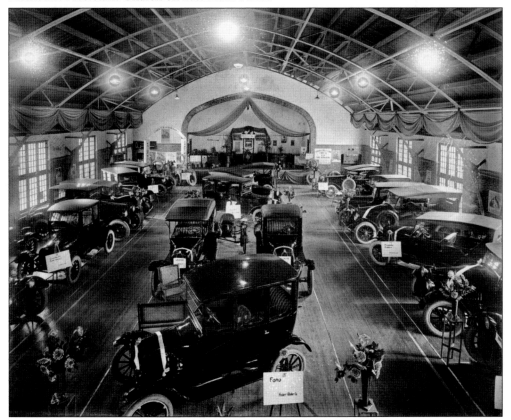

The armory on Longwell Avenue was the site of many events over the years. On October 28–30, 1920, American Legion, Carroll Post No. 31 sponsored an auto show in the armory. This proved to be the first of several shows, including the one in 1923 that is seen here.

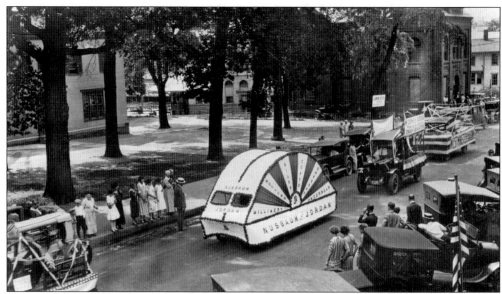

Westminster celebrated the Fourth of July in 1925 with a variety of festivities, including a firemen's carnival, baseball games, a dance, church suppers, and a parade. Saturday's parade featured floats from local businesses and decorated automobiles. This entry from Nusbaum and Jordan won the $25 prize for the best decorated float.

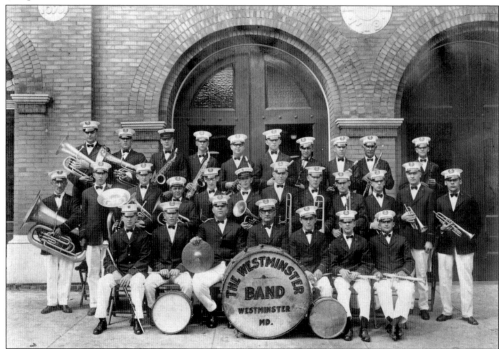

The Westminster City Band began operations in 1893. During World War I, many of the band's members joined the Maryland National Guard under the designation "First Regimental Band of the Maryland National Guard" and served in France beginning in 1918. With the return of many of its members after the war, the band resumed full operations. The group posed in front of the Westminster firehouse in this 1926 image.

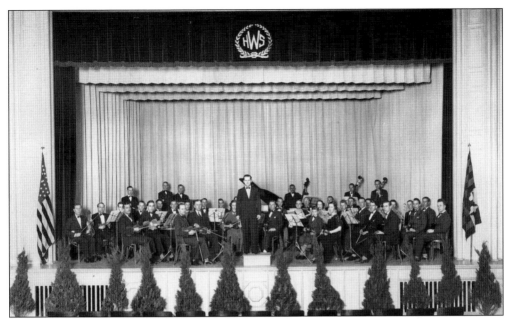

Almost from the day it was completed, the auditorium at the new Westminster High School on Longwell Avenue became the scene of many community events. This image shows the Carroll County Symphony Orchestra, with Philip Royer as conductor. A press release from 1938 reveals that the orchestra did not charge admission but took up a collection during intermission to cover the costs of the hall, music, and janitorial services.

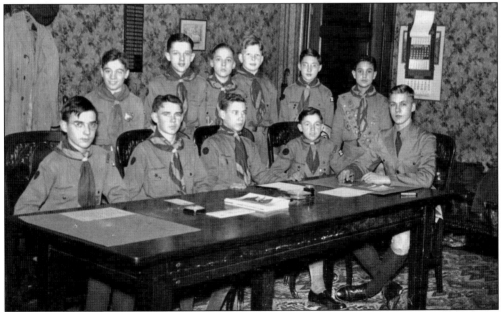

As part of National Boy Scout Week, Troop No. 321 elected several of its members to spend a day as Westminster's mayor, councilmen, and city officials. The Scouts who acted as city officials on February 10, 1940, were, from left to right, (first row) Paul Hilmer, Norman Aldridge, Charles Boyd, Miller Beard, and Harry Emigh Jr. (mayor); (second row) Raymond Valianti, Thomas Holmes, Harrington Smith Jr., William Schaeffer, Robert Stansbury, and John Donofrio.

Frock's Sunnybrook Farm at 112 Bond Street (above) was a popular location for a variety of events. There was a large banquet hall, which could be rented for weddings and parties, and a swimming pool. Frock's offered Sunday dinners and also held dances. Gene Frock and his Swingmasters had a large following and drew crowds whenever they performed. In this 1947 image (below), Gene Frock is conducting with Charlie Swinderman on piano, Willie Barnes on drums, Levine Saylor on guitar, Eddie Plunkert on trumpet, and saxophone players (from left to right) Richard Yingling, Lynn Fisher, and William Yingling. The business opened in the 1920s and was still going strong over 50 years later.

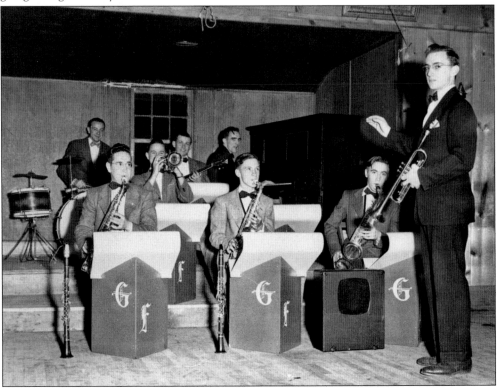

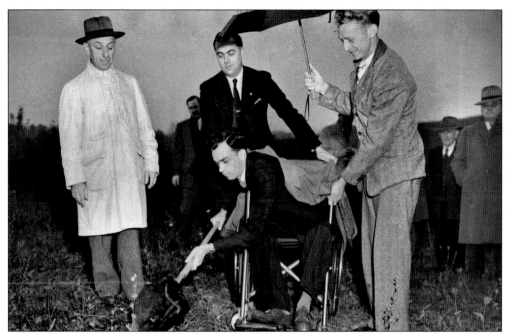

The Veterans of Foreign Wars (VFW) of the United States was organized in Ohio in 1899. In Westminster, the local post was chartered on June 19, 1919, and designated Molleville Farm Post No. 160. On November 11, 1946, the organization broke ground for a new building on Poole Road. Participating in the ceremonies were Thomas Manning and Paul Harris, both wounded veterans of the European theater of operations during World War II.

The VFW Drum Corps posed on the steps of the armory in 1949. Pictured are (first row) Doris Swartzbaugh, Dan Englar, Jim Turfle, Dick Hown, Bob Bowers, Bob Stansburg, George Zinn, Lee Manger, and Lois Guild; (second row) Bob Davis, ? Zollikoffer, Bob Whitehurst, Dick Eckenrode, Russ Martin, and Joe Evan; (third row) Bob Melown, Tom Holmes, Fred Crumpacker, Karl Byers, and Booker Miller; (fourth row) Jim Sharkey, Dick Miller, Charles Bowers, and Dick Haifley.

In 1912, William F. Myers moved from Pleasant Valley to Westminster and opened the William F. Myers Company at Liberty and Green Streets. In 1938, the William F. Myers Band began operations, sponsored by the meatpacking company and with many members of the old Pleasant Valley Community Band. This photograph of the band was taken in 1956. The band is still in operation, though the business closed in 1983.

The Order of DeMolay, founded in 1919, is an international youth organization for boys ages 12 to 21. At its peak, there were 21 chapters across the state of Maryland. John Byers took this photograph of a DeMolay dance held at the armory on November 15, 1946.

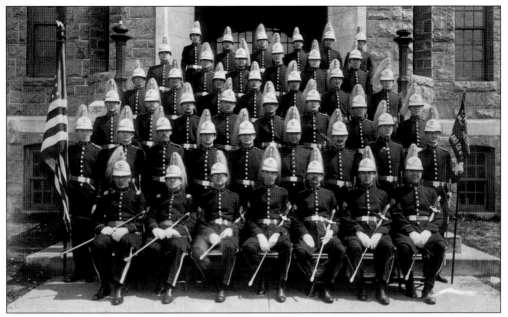

The Knights of Pythias was one of many fraternal organizations that appeared in the 19th century. Soon after the knights were founded, drill corps sprang up in lodges across the country. The Uniform Rank, Knights of Pythias, was created in 1878 to consolidate these corps. Westminster's Company No. 16 of the Uniform Rank was established in 1925. This undated image shows the Uniform Rank in front of the armory.

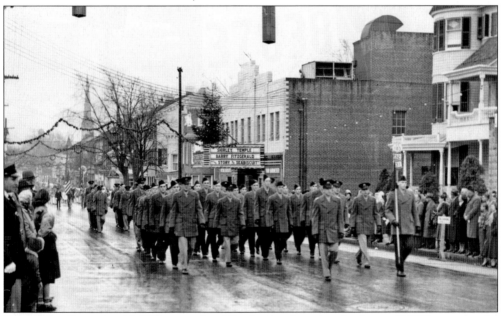

On Sunday, December 11, 1949, a parade of dignitaries, American Legion and VFW posts, bands, and the ROTC of Western Maryland College marched west on Westminster's Main Street to the World War II memorial at the Forks with Pennsylvania Avenue. Sen. Millard E. Tydings gave the keynote address at the ceremony, dedicating the monument in tribute to Westminster's soldiers "of all wars for the courage and valor displayed."

This photograph of a local poker club was taken in the dining room at Hoffman's Inn in 1955. The group of businessmen met frequently for dinner and cards. From left to right are (first row) Frank Leidy, Norman Boyle (grandson of John Brooke Boyle, who owned the building from 1872 to 1893), John Cunningham, Howard Brown, and Theodore Brown; (second row) Ben Thomas, Paul Whitmore, Miller Richardson, and Ralph Bonsack.

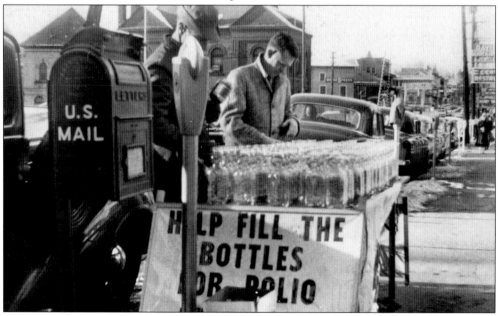

Polio was one of the most dreaded diseases of the 20th century, killing or paralyzing thousands including Pres. Franklin Roosevelt. Local residents mobilized to fight the disease in January 1957. The Westminster Civitan Club raised money by asking donors to "Help Fill the Bottles for Polio" in a sidewalk display on East Main Street. Citizens were encouraged to put their spare change in the bottle labeled for their street or community.

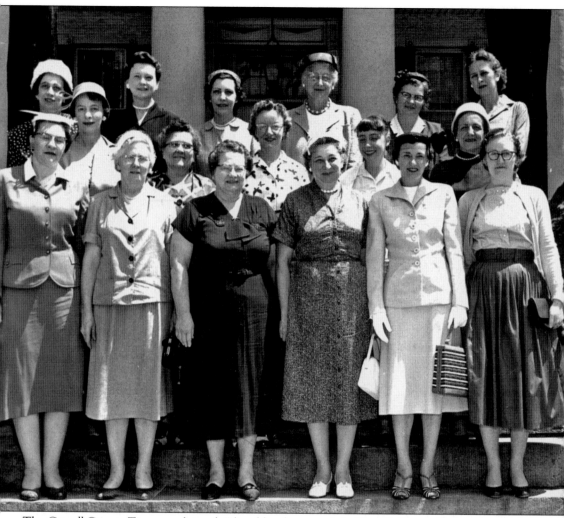

The *Carroll County Times* proclaimed, "the old order passeth in Carroll County" when the first women were sworn in for jury duty at the May term of the circuit court in 1957. Seven women were selected for the grand jury and 10 others for the petit jury. The *Democratic Advocate* noted that for the first time "in addressing the jury the attorneys will say 'ladies and gentlemen of the jury.' " The jurors posed on the steps of the courthouse in Westminster on May 13, 1957. From left to right were (first row) Mary Rineman, Nellie Hare, Minnie R. Leister, Margaret E. Stewart, Dorothy F. Cootes, and Pearl L. Bollinger; (second row) Estalla Frick, Marie Powell, Nellie Lantz, Katherine S. Chrysler, and Dorothy Stegman; (third row) Maude Seipp, Lynda Hahn, Ruth G. Elderdice, Lillian Chew, Ethel Devilbiss, and Dorothy Card.

The Westminster Community Pond was dedicated on September 18, 1954. The pond was a joint venture of the Kiwanis Club of Westminster and the Carroll County Chapter of the Izaak Walton League to provide outdoor recreation for families. The festivities included casting and archery demonstrations, wildlife displays, and a concert by the Westminster Municipal Band. Gov. Theodore McKeldin, seen here with Rickey Young, gave the dedication address and awarded prizes to the children participating in the fishing rodeo.

The Youth Fellowship of the Westminster Methodist Church sponsored a sunrise service at the Westminster Community Pond on Easter Sunday, April 10, 1955. The Chapel Choir, directed by J. Edward Moyer, provided the music, and Robert B. Pond of Johns Hopkins University offered the meditation. The public was invited to the service and encouraged to bring folding chairs.

www.arcadiapublishing.com

Discover books about the town where you grew up, the cities where your friends and families live, the town where your parents met, or even that retirement spot you've been dreaming about. Our Web site provides history lovers with exclusive deals, advanced notification about new titles, e-mail alerts of author events, and much more.

Find Your Place in History.